ALSO EDITED BY HERBERT D. SCHIMMEL,
WITH LUCIEN GOLDSCHMIDT

*Unpublished Correspondence of
Henri de Toulouse-Lautrec*

THE

HENRI DE TOULOUSE-LAUTREC

W.H.B. SANDS CORRESPONDENCE

EDITED BY

Herbert D. Schimmel

AND

Phillip Dennis Cate

DODD, MEAD & COMPANY · NEW YORK

Published by Dodd, Mead & Company, Inc.
79 Madison Avenue, New York, N.Y. 10016
Distributed in Canada by
McClelland and Stewart Limited, Toronto
Manufactured in the United States of America
Designed by Abe Lerner
First Edition

LIBRARY OF CONGRESS CATALOGING IN PUBLICATION DATA

Toulouse-Lautrec, Henri de, 1864-1901.
 The Henri de Toulouse-Lautrec, W.H.B. Sands
correspondence.

 Bibliography: p.
 Includes index.
 1. Toulouse-Lautrec, Henri de, 1864-1901.
2. Lithographers—France—Biography. 3. Sands,
W.H.B. I. Sands, W.H.B. II. Schimmel, Herbert D.
III. Cate, Phillip Dennis. IV. Title.
NE2349.5.T68A3 1983 769.92'4 83-14220
ISBN 0-396-08192-4

The monogram and lettering used on the front cover were designed by
George Auriol and published originally in *Le Premier Livre des cachets,
marques et monogrammes dessinés*, par George Auriol, Librairie Centrale
des Beaux-Arts, Paris, 1901.

Acknowledgments

These letters and writings by Toulouse-Lautrec, W. H. B. Sands, Henry Stern and Arthur Byl were purchased by Herbert D. Schimmel in 1971 from an American autograph dealer who had acquired them from an English colleague. They were contained in a "Tin Box" and were in the possession of a representative of Sands when bought by the English dealer. Some of the original group were sold by the American dealer prior to the Schimmel acquisition and have not been relocated by him; others have been located and restored to the collection.

The editors wish to thank the following persons for their help in various phases of preparing this book for publication.

Jean Adhémar, formerly of the Bibliothèque Nationale, Paris; Minna K. Bond; Mme. M. G. Dortu; Mariel Frèrebeau Oberthür, Adjunct Curator, Musée Montmartre, Paris, for her research on Arthur Byl; J. Girodon of Hernu Peron for his brief history of that company; Lucien Goldschmidt; Jean-Alain Méric; Robert Nikirk, Librarian, The Grolier Club, New York; Kenneth Rendell for his help in locating and restoring some letters to the collection; Wolfgang Wittrock, Düsseldorf; and the Department of Prints and Drawings of The British Museum, London.

Contents

Illustrations

Illustrations

Illustrations

THE
HENRI DE TOULOUSE-LAUTREC–W. H. B. SANDS
CORRESPONDENCE

HENRI DE TOULOUSE-LAUTREC

PHOTO ATTRIBUTED TO PAUL SESCAU

Treize Lithographies AND *Yvette Guilbert*

THE ACTORS AND ACTRESSES OF

HENRI DE TOULOUSE-LAUTREC

The depiction of Parisian entertainers dominates the graphic work of Henri de Toulouse-Lautrec from his earliest lithographic posters and prints. In fact, this subject surfaces in almost half of his total print output. He was interested in specific entertainment personalities rather than in the performer as a kind of genre or *type parisien* as executed by French artists such as Gavarni, Gustave Doré, and Honoré Daumier. Unlike Edgar Degas, Lautrec was not interested in the stage figure solely as a compositional investigation. Nor does one find in Lautrec's prints an idealized world of gay nineties entertainment, as depicted in Jules Chéret's titillating posters or as found in Alphonse Muchas's luminescent color lithographs.

In his portrayals of dance hall performers such as La Goulue, Valentin-le-Désossé, and Jane Avril; of café-concert entertainers such as May Belfort, Polin, and Yvette Guilbert; and of actors and actresses such as Sarah Bernhardt, Marcelle Lender, and Réjane, Lautrec recorded that which made them different and special. It was their idiosyncratic gestures, facial features, costumes, and individual styles of performance that intrigued him immensely. With little concern for flattery, less for unnecessary detail, but much for essence of personality, these works constitute a unique anthology of 1890s entertainers.

In addition to the numerous paintings, lithographic posters, single prints, and illustrations of performers created by Lautrec during the 1890s, he also produced four separate albums of lithographs devoted to entertainers. In 1893 he and his young friend Henri Ibels (1867–1936) each drew eleven black-and-white lithographs for the album *Café-Concert*. Published by André Marty, editor of *L'Estampe originale,* with text by Georges Montorgueil, Lautrec's prints

Introduction

depict Jane Avril, Yvette Guilbert, Paula Brébion, Mary Hamilton, Edmée Lescot, Caudieux, and Aristide Bruant among others (Delteil 28–38).*

An Yvette Guilbert album of a cover and sixteen lithographic portraits again published by Marty and written by Gustave Geffroy followed in 1894 (Delteil 79–95). Four years later in 1898 Lautrec's second Yvette Guilbert album was published by W. H. B. Sands of London, this time with a cover, a frontispiece, eight lithographic portraits, and a text by Arthur Byl translated into English (Delteil 250–255, 257–260). These three albums have been well documented as to date of execution, edition size, publisher, and identification of subjects. One last album, *Treize Lithographies,* however, has been cloaked in mystery.

In recent years a group of forty-seven letters has come to the surface—correspondence between Lautrec and the English publisher, W. H. B. Sands; between Sands and printer Henry Stern; and between Sands and author Arthur Byl. This correspondence relates in detail the genesis of this series of prints and, surprisingly enough, that of the Guilbert album. These letters reveal that the generally accepted date of execution, size, and number of editions as well as identification of many of the subjects for *Treize Lithographies* are incorrect. These errors have been based upon guesswork that began with the efforts of Delteil in 1920, was repeated by Joyant in 1926–1927, and continued with Adhémar's revised catalogue raisonné of 1965.† At the very least these letters serve as a lesson in the vulnerability of certain tools, in this case the catalogue raisonné, relied upon by historians. Beyond that the letters offer the fascinating story of the creation of two important theatrical print series, and in so doing they reveal something of Lautrec's creative process, and the relationship among publisher, printer, and artist, as well as Lautrec's collaboration with the enigmatic literary figure Arthur Byl.

The letters are in the possession of Herbert D. Schimmel. Over the past thirty years he has amassed not only the largest private collection of Lautrec correspondence, together with an outstanding collection of Lautrec prints, posters, and drawings complemented by works of Lautrec's artistic cohorts and by other period *objets d'art,* but also the most extensive library of Lautrec-

* In 1893 and 1894, in the journal *Le Figaro Illustré,* Lautrec's drawings were photomechanically reproduced in color for Gustave Geffroy's articles "Le Plaisir à Paris: Les Restaurants et les Cafés Concerts des Champs Elysées," no. 40, July 1893, and "Le Plaisir à Paris: Les Bals et le Carnaval," no. 149, February 1894.

† See the bibliography for details of these publications.

Introduction

related *fin de siècle* materials. In 1969 Lucien Goldschmidt and Herbert Schimmel edited the Phaidon publication *Unpublished Correspondence of Henri de Toulouse-Lautrec,* which translated and annotated the 273 letters that at the time comprised the Schimmel collection. Since then the collection has grown. A most significant acquisition is the group of forty-seven letters presented here. It must be noted that these letters were represented as a collection and purchased as such in 1971 from an American dealer.* It was subsequently learned that several "unimportant" cards and letters from the original group had been sold previous to the Schimmel purchase, and these have not since been located. This loss could account for some of the gaps within the sequence of letters; we do not feel, however, that the essential narration produced by these letters has been greatly affected.

Herbert Schimmel initiated the present publication and is responsible for much of the preliminary research and footnote material. I am most grateful to him for allowing me to participate in the analysis of this unique and revealing Lautrec correspondence.

The catalogues of Delteil and Adhémar place the date of execution of the *Treize Lithographies* at 1895, and according to the most recent fanciful interpretation of the series, the album "commemorated the 1895 Paris season by representing well-known personalities currently onstage."† The letters show, however, that the album was first considered as a possible project as late as July 1896 and was far from realization then. In June of that year Lautrec visited England with Louis Bouglé—called Spoke—the manager of a company that manufactured the Simpson bicycle chain. Spoke was a friend of Sands and, indeed, may have introduced him to Lautrec during their visit. Sometime earlier that year, Lautrec produced the color lithographic poster *La Chaîne Simpson* (Delteil 360), while in December 1898 his lithograph of the actress *Polaire* (Delteil 227) was reproduced in the inaugural issue of Sands's journal *The Paris Magazine,* for which Spoke wrote a column on bicycling.

In the first letter of this group of correspondence—dated July 6, 1896—Lautrec acknowledges Sands's interest in collaborating on a book. Further letters reveal that this book is Sands's early concept of what is finally realized as the *Treize Lithographies* album. The germination of this project took at least

* See the acknowledgments for the details of the purchase of these letters.

† Colles Baxter, "Mistaken Identities: Three Portraits by Toulouse-Lautrec," *The Print Collector's Newsletter,* vol. X, no. 2, May–June 1979, p. 42.

Introduction

another year. In a letter to Sands of June 2, 1897, Lautrec states that he is considering various authors for the project—Gustave Geffroy, Lucien Descaves, Tristan Bernard—and that they could print an English and a French edition. He also remarks that the book could not be completed before Christmas 1897. By the end of 1897 the number of actors and actresses to be depicted was still undecided. Sands at one time had suggested thirty personalities. In an undated letter that was clearly written in the winter of 1897–1898 Lautrec states that twenty portraits "would be more certain of success." The compromise that was reached called for twenty-five different subjects. By February 25, 1898, Lautrec had completed eight drawings on stone—Sarah Bernhardt, Yvette Guilbert, Polaire, Anna Held, Polin, May Belfort, Émilienne d'Alençon, Jeanne Granier —and Sands proposed the end of March as the date for printing an edition of 200 to 250 of the complete series. Earlier—in January—Arthur Byl finally had been selected by Lautrec to write a biographical sketch for each personality; by February 25, Byl had produced the text for six—Sarah Bernhardt, Coquelin Aîné, Emma Calvé, Polaire, Yvette Guilbert, and Edmond Rostand. The actors and actresses album was well on its way.

Two weeks earlier, however, Sands had considered eliminating Yvette Guilbert from the album. Now, on February 28, he conceived of a second publication devoted exclusively to Guilbert. In this letter he requests that Lautrec send him "6 drawings of Yvette G. immediately. . . . I think that these drawings would be in great demand at the beginning of May when she will be here." He added, "This would be something for both of us, and also a little publicity —all the better—for you, because it will be fashionable society which will see them." Thus the original project developed into two and initiated an intense period of correspondence between Sands and Lautrec.

From February 28 through June 7, 1898, twenty-nine letters flow between the two, with twenty-three of them coming from Lautrec. The artist is at first not quite certain of the meaning of Sands's request: does the publisher want six more proofs of the Guilbert lithographs originally produced for the actors and actresses album? Sands responds on March 1: "Can you give me 6 drawings like the one which you already sent me—it doesn't matter which ones—on paper." And on March 13 Sands states: "I now have 4 Yvettes—my idea is to make an album—how many drawings do you think will be necessary? As I have told you, 6 in my opinion."

Throughout the sequence of letters concerning the Guilbert album the actual

number of lithographs to be produced is ambiguous. One is not certain, for instance, whether the Yvette portrait rejected from the actors and actresses book is to be used in the Guilbert album. Nevertheless, on March 20 Lautrec writes: "You have received one more Yvette. That makes 6. I will make two more as you request." Sometime between the thirteenth and twentieth of March, therefore, Sands had increased the size of the album to eight images. By March 27 Lautrec had completed the stones for the eight lithographs.

On April 7 Lautrec asked whether Sands would like the cover printed lithographically or photomechanically, "the same process as that for the Nursery Toy Book."* Lautrec's first effort for the cover (Delteil 251), which he himself thought good, was rejected by Sands and used as the frontispiece.

At this point time was running short for the completion of the Yvette Guilbert publication intended by Sands to coincide with her May performance in London. Sands arranged for the translation of the Byl text into English by hiring the foremost translator of the day, Dutch-born and English-educated Alexander Teixeira de Mattos (1865–1921), who had translated the Lutetian Society's edition of Zola.

Guilbert's premier performance of the 1898 London season scheduled for May 2 also coincided with the opening of Lautrec's one-man exhibition at the Goupil Gallery on Regent Street. On April 24, just before leaving for London, Lautrec wrote that he and Yvette would sign their names on lithographic transfer paper which could then be transferred to stone for the printing of the album.†

Lautrec's exhibition opened May 2 to mixed reviews although the general tenor was unfavorable, comments such as "revoltingly ugly," "really monstrous," and "vulgar" appearing in the London newspapers and magazines. It was attended by "fashionable society" including the Prince of Wales.

One assumes that the album was published on time since there exists in the Schimmel collection an unusual copy signed by Lautrec purportedly in the

* The cover for *The Motograph Moving Picture Book,* published by Bliss, Sands and Co. in 1898, was illustrated photomechanically after a drawing by Lautrec.

† In 1930 nine stones, including the frontispiece and eight portraits, were in the possession of Ernest Brown and Phillips, The Leicester Galleries of London, which reprinted them in a volume entitled "Yvette Guilbert—A Series of Nine Lithographs by H. de Toulouse-Lautrec with a critical essay by Maurice Joyant and a Reminiscence of Lautrec by Mme. Yvette Guilbert." The stones were then donated to the Toulouse-Lautrec Museum in Albi, where they are now situated.

office of Sands.* This was to be Lautrec's last trip to London, and he would have no further opportunity to visit Sands. The great disappointment for Sands, however, must have been the last-minute cancellation of Guilbert's London season. The final letter relating to the Guilbert album is from Yvette to Lautrec and is dated May 6. "We [Guilbert and her husband] are in Carlsbad! The lady [Guilbert] had such pains that the doctors made her leave Paris immediately! . . . I have had to postpone my season in London until next year." It would be three more years before she returned to London.

From mid-January 1898, Paris and all of France had been torn apart by the Dreyfus affair; and how that shattering event had influenced Lautrec, Sands, and Guilbert, if at all, in relationship to this project can only be conjèctured. Or it may have been a flare-up of her kidney illness which caused the cancellation. Some months earlier, on June 22, 1897, Guilbert had married Max Schiller, a Roumanian Jew brought up in Berlin, and though at that time she considered herself a free thinker, her devoutly Catholic mother refused to attend the ceremony. On January 13, 1898, Georges Clemenceau's newspaper *L'Aurore* had published Emile Zola's "J'Accuse!" an open letter to French President Félix Faure which had laid bare the facts of the affair and had ended with a series of accusations each beginning "I accuse."

An avalanche of letters from around the world responded to Zola's appeal, and like the rest of the world the English public was revolted at the extent of the moral decay in French life. On February 7, 1898, Zola had been brought to trial on a charge of criminal libel and on February 23, 1898, was found guilty and sentenced. Trial revelations had caused a tidal wave of anti-Semitism that engulfed France.

In London *The Times* had said "he [Zola] will be honored wherever people are free." Guilbert's leaving France with her husband and going to Germany must have seemed the proper cure for whatever ailed her in early May 1898.

On July 18, 1898, the appeal of Zola's conviction was to begin, but he decided his jailing would not help the Dreyfus cause and chose exile to England.

Lautrec never seemed to be directly affected by or interested in the Dreyfus affair; and although many of his closest friends were Dreyfussards, there is almost nothing in his oeuvre relating to it. On April 20, 1898, Georges Clemen-

* Letter from A. G. Hodge, Glasgow, to Herbert D. Schimmel, June 7, 1957. William Hodge and Co. was one of Sands's printers, and one of the Hodges had asked Lautrec to sign his copy of the album when meeting him at Sands's office.

Introduction

ceau's novel *Au Pied du Sinai* was published* with illustrations by Lautrec (Delteil 235–249). The book was a study of Jewish life in the ghettos of Poland, and Lautrec had spent time in the Jewish quarter of Paris observing characteristic dress and activities before doing the drawings. They are accurate and artistic and contain none of the viciously anti-Semitic caricature that prevailed in the daily and weekly Parisian artistic journals.

During the two months of correspondence concerning the Guilbert album Lautrec, Byl, and Sands were also working prodigiously on the production of the actors and actresses book. By February 28 Guilbert no longer was to be included in the larger project. By March 5 Lautrec had completed or at least made studies of the first ten lithographs for the book: *Polaire, Belfort, Held, Polin, Bernhardt, d'Alençon, Granier, Calvé, Rostand,* and *Coquelin*. It was on that date that Lautrec sent a list, compiled by Byl, of seventeen performers from which Sands was to select the remaining fifteen subjects of the projected twenty-five portraits.

1. Réjane	7. Cléo de Mérode	13. Brasseur
2. Febvre	8. Invernizzi	14. Antoine
3. Marsy	9. Delna	15. Sully
4. Balthy	10. Sanderson	16. Mendès
5. Hading	11. Ackté	17. Little Tich
6. Guitry	12. Ugalde	

Within the next two weeks Sands selected eight names from Byl's list.

1. Réjane	4. Hading	7. Sully
2. Febvre	5. Delna	8. Mendès
3. Marsy	6. Sanderson	

In the interim Byl produced six more biographical sketches or medallions—for Balthy, Sully, Marsy, d'Alençon, Hading, and Polin. Balthy, however, had not been selected from Byl's list. Therefore, on March 25 Sands asked that Lautrec replace Balthy with Delna and replace Mendès with Ackté and that Guitry and Antoine be added to complete the group, which had now been reduced by Sands from twenty-five personages to twenty, Lautrec's original

* Georges Clemenceau, *Au Pied du Sinai*, Henry Floury, Paris, 1898. Illustrations by Henri de Toulouse-Lautrec.

suggestion. The identity of the twenty subjects was reiterated in a letter from Sands to Lautrec on March 28.

1. Polaire	8. Calvé	15. Hading
2. Belfort	9. Rostand	16. Guitry
3. Held	10. Coquelin	17. Sanderson
4. Polin	11. Réjane	18. Ackté
5. Bernhardt	12. Febvre	19. Antoine
6. d'Alençon	13. Marsy	20. Sully
7. Granier	14. Balthy	

On April 1 Lautrec made one last revision in Sands's selection, replacing Ackté with Cléo de Mérode because, as Lautrec put it, she was a more sympathetic subject. Thus by April 1, 1898, the content of the actor and actresses book was finally agreed upon by artist, author, and publisher. Further, at least twelve of the lithographs and twelve of the medallions, though not all corresponding in subject, were completed by that date. The selection of subjects had essentially been directed by Lautrec and Byl, who allowed Sands just enough input to fulfill his perceived role as editor. It was from this group of twenty that the final thirteen actors and actresses derived.

Up to this point the evolution of the publication, as revealed by the correspondence, was relatively straightforward; however, in April the project began to flounder and by the end of May not only was the book greatly altered but its completion was in doubt. By the end of April Byl had produced eighteen of the twenty medallions. On May 1 Sands informed Byl that the eighteen were sufficient "for the present." Sands, apparently losing enthusiasm for the project, curtailed it. With the combination of Lautrec's less than favorable London opening and the failure of Guilbert to appear in her London concert it is no wonder that Sands may not have been enthusiastic. On May 31, responding to Lautrec's inquiry of the previous day regarding the delivery to Sands of "all of the stones (15) and four proofs," Sands complained about the price charged by the printer, Henry Stern, for the stones. In addition he stated that the stone for *Balthy* "will be no use, so I am returning it to M. Stern." Later, in early June, Lautrec told Sands to keep *Balthy,* "so much the better if you can publish it." The letters therefore reveal that in the beginning of the summer of 1898 Sands had in his possession eighteen medallions and at least the stones for a total of fifteen lithographic images commissioned specifically for the actors and

Introduction

actresses book. Of the fifteen stones delivered to Sands, thirteen were eventually printed in the album and two, *Polaire* and *Réjane,* ended quite differently, as is noted. Although he implied to both Byl and Lautrec that he might continue the project in the fall, there is no correspondence or other supportive evidence of further collaboration. Sands spent close to $600 on both projects even prior to printing the Guilbert album. The cancellation of Guilbert's London performance had made the financial potential for the singer's album far less lucrative. The possible failure of one project may have made Sands have second thoughts about the simultaneous production of an even larger one. Indeed it is questionable that Sands himself published the *Treize* album at all.

The possible failure to publish may have been due to a reorganization of the company, which is indicated by the changing of its name from Bliss, Sands & Co., publishers of the Guilbert Album in May 1898, to a successor, Sands & Co. which published *The Paris Magazine* and the Polaire drawing in December 1898. This can never be fully determined because the company's records were lost during the Second World War.* We know that at the same time Sands was scheduled to publish *Celebrated Criminals,* an album of six drawings by James Pryde. He never issued this portfolio; it was brought out some years later by a different publisher.†

Various bits of evidence suggest that the *Treize Lithographies* was not published prior to February 1899, and not by Sands. In December 1898 volume I of the London monthly journal *The Paris Magazine* was published by Sands and Company in collaboration with Clarke and Company in Paris. In the January issue there is a large advertisement for the 1898 *Yvette Guilbert* album and for *Le Motographe Album,* both published by Sands in collaboration with Lautrec. If Sands had published the *Treize Lithographies* by January 1899, it seems logical that the album would also have been advertised in *The Paris Magazine.*

In the December issue Sands reproduced Lautrec's lithograph of *Polaire* (Delteil 227). Originally produced for the actors and actresses series, it is not included in the *Treize* album. In October 1899 Sands asked Lautrec for a letter indicating the former's ownership of the *Polaire* image. Lautrec's letter to Sands

* Letter from G. V. B. (Manager, Sands & Co. Ltd.), London, to Herbert D. Schimmel, October 23, 1956.

† Catalogue of a Hundred Works by James Pryde in *Fine Art*, The Studio Ltd., London, 1931, page 119. The later publisher was Sir Joseph Causton at the Clapham works.

Introduction

of October 28, 1899, states, "I declare by these presents that I have sold to Mr. Sands, publisher in London, the portrait of Polaire which was reproduced in *The Paris Magazine* and this drawing therefore belongs to Mr. Sands with all rights." The question arises then why Sands would need this declaration of ownership. Was he selling the other actors' and actresses' images to another publisher such as Pellet? Was the *Polaire* image not acceptable to the other publisher because it had already been reproduced in the journal? If so, was Sands now assuring his ownership of *Polaire* in view of the sale of the other images?* One can only speculate. Nevertheless, *Treize Lithographies* is a very simplified version of Sands's envisioned actors and actresses book. It lacks Byl's anecdotal biographical medallions; it omits any identification of the publisher or the date of publication. Thus, since there is little evidence that Sands actually published the album, it seems likely that he sold the stones, but to whom?

Adhémar states in his 1965 catalogue raisonné of Lautrec's prints and posters:

The circumstances of the publication of this set are not well known. Yet Sagot does mention that it was published by Sands, who handed it over to the Société des Amateurs Indépendants, which had 30 copies of it printed. It was bought up by Pellet, who offered 300 copies of it on 19 May 1906. There may have been a printing for the Vingt (or else copies reserved for them in 1895).†

We have found no evidence to back up Adhémar's assertions. On the contrary, we find no record of the existence of an organization called Société des Amateurs Indépendants, although we did note the existence of the Société des Bibliophiles Indépendants.§ Nor could the Vingt, as Adhémar calls Les XX, confusing it with the Belgian organization, have reserved twenty copies in 1895, since the group was not formed until 1897. Adhémar again was assuming 1895 for the date of publication.

La Société des XX, organized by Pierre Dauze in 1897, was a group of bibliophiles.‡ Dauze was an avid book collector as well as an editor of such publi-

* In 1930 the *Polaire* stone was in the possession of the publishing firm of Helleu et Sergent, Paris. There 75 copies were reprinted and then the stone was donated to the Toulouse-Lautrec Museum in Albi, where it is now situated.

† Adhémar, *Toulouse-Lautrec, His Complete Lithographs and Dry-points,* see note for Adhémar 166.

§ Clement-Janin, "Les Éditions de Bibliophiles," *Almanach du Bibliophile pour l'Année 1901,* pp. 221–249, Édouard Pelletan, Paris, 1903.

‡ For information on Les XX see Raymond Hesse, *Histoire des Sociétés de Bibliophiles en France de 1820 à 1930,* L. Giraud-Badin, Paris, 1929, pp. 49–56 and *Les XX Exercises 1913–1917,* Paris, 1918.

Introduction

cations as *Répertoire des Ventes Publiques Cataloguées, Revue Biblio-Icono-graphique,* and *Bibliographie Mensuelle* and later was founder of La Société du Livre Contemporain. Les XX allowed a maximum of twenty members, each of whom paid an entrance fee of 100 francs (thirty francs for founding members) and annual dues of 200 francs. With these approximately 4000 francs, the Société commissioned a special printing of selected works by promising young or recognized older authors from various publishers. The works varied from illustrated and unillustrated novels by such authors as J. K. Huysmans and Anatole France to didactic publications such as the catalogue raisonné of Steinlen by de Crauzat and *L'Art Social* by Roger-Marx. In fact, it was probably Roger-Marx, founding member of Les XX as well as friend of and writer on Lautrec, who recommended that the Société publish its own special edition of the *Treize.*

Les XX editions were always limited to a run of twenty. Each publication was printed on the Société's own Arches vélin paper with a "XX" watermark, and each had a special cover distinct from that of the trade printing. Such novels as Huysmans' *La Bièvre, Les Gobelins,* and *Saint-Séverin* (1901) were illustrated with color woodcuts by Auguste Lepère; and Jean Louis Forain's *Album* of photo relief illustrations after his own drawings was printed with no text; but the *Treize* is the only album printed for Les XX consisting totally of original prints and no text.

The Société's edition of the *Treize* is composed of two printings of each lithograph, one on cream-colored vélin paper mounted on bristol board and another on white wove paper also mounted on bristol board. A third printing of one of the lithographs (the particular subject varies from one album to another) serves as a frontispiece with the title, "Treize Lithographies par H. de Toulouse-Lautrec," superimposed over the image in green type. All of these twenty-seven sheets are enclosed within a cream-colored heavy stock portfolio imprinted at the lower right with the words "Tirage Spécial pour 'Les XX.'"*

In the final analysis what does one know about the publication of *Treize Lithographies?* Sands had originally projected that the actors and actresses book would be published in an English edition of 250 and a French edition of 100. We know for certain that the album was published by Les XX in an edition of twenty probably sometime after February 1899 but before 1913 when it

* The copy observed is in the Department of Prints and Drawings of the British Museum (Inventory no. 1920–8–20, 1–26).

Introduction

is listed among the publications of the Société. Unfortunately, unlike 117 of the 120 works listed, its publication date is omitted. The thirteen individual lithographs were sold at the Georges Viau sale December 6 and 7, 1909, numbers 145–50, under the following names: *Coquelin, Polin, Loie Fuller, Polaire, Lender en Voiture, Cléo de Mérode, Sarah Bernhardt dans Cléopâtre, Granier, Cassive, Lender, Subra, Guitry, Lavallière en Voiture*. The album is also listed among the works of Lautrec in *Kunst und Künstler* of April 1907. We also know that at least one other edition of unknown quantity was published on unmounted wove paper, most likely simultaneously with that of Les XX's. Examples of the album may also be found on china paper.*

While this information on the actual publication of the album is incomplete, the correspondence does allow one, through a process of elimination, to identify all the subjects of the *Treize Lithographies* as well as to reattribute and to connect with the actors and actresses project other lithographs from Lautrec's oeuvre.

As stated earlier the subjects for the *Treize Lithographies* derived from the group of twenty personalities agreed upon by Sands and Lautrec. The traditional identification of seven lithographs from the album corresponds with subjects within that list of twenty and may be considered correct. These attributions are also confirmed by comparing photographs of the individual performers with the lithographs.

> *Sarah Bernhardt* (Delteil 150)
> *Cléo de Mérode* (Delteil 152)
> *Coquelin Aîné* (Delteil 153)
> *Jeanne Granier* (Delteil 154)
> *Lucien Guitry* (Delteil 155)
> *Polin* (Delteil 159)
> *Émilienne d' Alençon* (Delteil 161)

The standard identification of the six other subjects does not agree with the remaining thirteen names on the 1898 list. It is only by comparing contemporaneous photographs of these thirteen performers with the six lithographs that one may more accurately determine their identity. Each of the unidentified lithographs depicts a female. There are nine women remaining on the 1898 list:

* The Cabinet des Estampes of the Bibliothèque Nationale, Paris, has a copy of the album with the lithographs printed on china paper.

Introduction

Polaire	Calvé	Balthy
Belfort	Réjane	Hading
Held	Marsy	Sanderson

Polaire was reproduced in *The Paris Magazine* of December 1898 and, as we know, was not included in *Treize Lithographies*. One may also discount Réjane; she does not resemble any of the remaining six lithographs. On the other hand a photograph of Réjane as Paméla in Victorien Sardou's play of the same name appears in the journal *Le Théâtre* of March 1898. This photo relates closely to a Lautrec lithograph of *Réjane* (Delteil 266). The date of this print has not been agreed upon or substantiated by Delteil or Adhémar.* We believe that it was created by Lautrec in 1898 for the actors and actresses project because of its basic similarity in execution, composition, and dimensions to the lithographs in the *Treize Lithographies* and because it is included in the list of twenty subjects.†

The elimination of Réjane and Polaire leaves only seven personalities from which to identify the remaining six lithographs of the album. Photographs reveal not only that Belfort, Held, Marsy, Balthy, Hading, and Sanderson are the subjects but also that Lautrec was inspired in some cases by photo-reproductions found in current theatrical publications. This is particularly evident in the lithograph of *Sybil Sanderson,* which coincides in many ways with the reproduction in *Le Panorama, nos Jolies Actrices* of 1897–1898 and also with *Coquelin Aîné* and *Sarah Bernhardt,* which directly relate to photo illustrations in the January 1898 issue of *Le Théâtre.* This was the first issue of the journal and, as such, served as a new and immediate source of imagery for the artist, something for which he was always searching.

Each of the thirteen published portraits is on a vertical axis with a bust, half-length, or, in the case of *Polin,* full-length figure pulled up close to the picture plane. The figure imposes itself against a neutral or simplified background consisting of a column, a curtain, or the suggestion of an audience. The portraits are freely sketched, the broad strokes of black retaining the texture of the crayon. Formality is avoided by the liveliness of line and by the diagonal place-

* Delteil places the date of execution of the print at 1899 while Adhémar (57), concurring with Joyant, designates the year as 1894.

† In a situation similar to that for the disposition of nine lithographic stones for the Yvette Guilbert album, the *Réjane* stone was also in the possession of Ernest Brown and Philipps, The Leicester Galleries of London. This stone, like the others, was donated to the Toulouse-Lautrec Museum in Albi where it is now situated.

ment of the figure, which suggests movement onto or off the picture plane. The dimensions of the thirteen lithographs vary slightly between 278 mm and 298 mm, vertical measurement, and between 239 mm and 246 mm, horizontal measurement. The range of the dimensions widens very little when one includes those for *Polaire,* 342 mm x 222 mm, while *Réjane* measures 288 mm x 221 mm. Lithographs created by Lautrec for the initial actors and actresses book would be fairly consistent with these dimensions and also similar to the thirteen published prints in execution and format. There are very few other lithographs among Lautrec's work which fit all these criteria. Those which do are two impressions of *Jeanne Granier* (Delteil 264, 265), two impressions of *Jane Hading* (Delteil 262, 263), the portrait identified by Delteil as *Calmèse* (Delteil 291), the rather innocuously titled print *On Stage* (Delteil 213), and *Mme. L . . . or At the Glove Shop* (Delteil 225).

In the letter to Sands of March 5, 1898, Lautrec indicated that he had created one portrait of Jeanne Granier but was not satisfied and would "do a better one." It is likely that the two other portraits of Granier, so similar in size and style to the *Granier* included in the album, are his preliminary efforts. Although Lautrec does not discuss it, the two *Jane Hadings*, which vary slightly from the portrait in the album, must also have been produced in connection with the actors and actresses project.

The February 1898 issue of *Le Théâtre* includes a photo-illustration of Mlle. Leconte (née Marie-Anne Leconte) as Blanche Vallon in the play *Catherine* by Henri Levedon. The features and the pose of the actress are similar to that of the figure in the lithograph *Mme. L . . . or At the Glove Shop*. The fact that the initial of the actress's last name agrees with that in the title of the lithograph is more convincing evidence that "Mme. L." as actually Mlle. Leconte and that Lautrec relied upon the image in *Le Théâtre* as a source for his print. At least since 1902, when a copy of the lithograph was first up for auction, it has had the descriptive title *At the Glove Shop* appended to it.* This title, however, bears no real relation to the scene depicted, nor does it relate to the play *Catherine* or the role performed by Leconte. It is more likely that the title was given to the print at the time of the auction as a better means of identification. *Mme. L . . .* is an appropriate image for the actors and actresses book; it has no other rationale within Lautrec's oeuvre but to be an early effort for the book, an effort which was rejected by the artist when in March the final selection of subjects was made.

* The Pochet sale in 1902 lists this lithograph as *Chez la Gantière:* see Delteil 225.

Introduction

On March 16, 1898, Lautrec wrote to Sands, "I will have several more drawings (lithographs) to send you in 3 or 4 days—Calvé, Rostand, etc." Two days later Sands responded, "For the other book—I believe that you have already done six—you are in the process of also doing Calvé, Rostand, Coquelin, Granier. . . ." Based on these two statements we assume that the lithographs for Emma Calvé (the actress) and for Edmond Rostand (the creator of *Cyrano de Bergerac*) were produced by Lautrec. However, there are no lithographs specified as such within his oeuvre. Drawing upon the last two prints which agree in size, style, and format with work in *Treize Lithographies,* it is possible to reattribute the portrait of *Calmèse* to *Rostand* and the lithograph entitled *On Stage* to *Calvé.*

Although we are unable to locate a photograph of Calmèse, the photograph of Rostand reproduced in *Nos Auteurs et Compositeurs Dramatiques* of 1897 is a mirror image, including the protruding mustache but without the hat, of the distinguished gentleman depicted in Lautrec's lithograph. On the other hand, Calmèse was far from being a gentleman. Berthe Sarrazin, Lautrec's housekeeper during the difficult days of the artist's dissipation in early 1899,

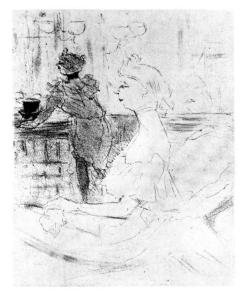

Madame L. ou Chez la Gantière.
LITHOGRAPH, 1898. DELTEIL 225.

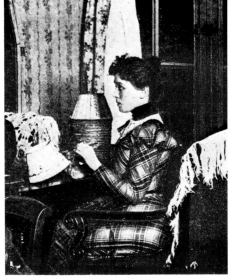

Marie-Anne Leconte (photo reversed), in *Catherine.* Reproduced from *Le Théâtre* No. 2, February 1898.

[29]

Introduction

considered Calmèse a "pig." He was in fact an owner of a livery stable; he was uncouth, an alcoholic, and an opportunist who promoted Lautrec's excessive drinking and took advantage of the artist's weakened mental facilities for his own aggrandizement. While the horse motif in the background of the print could signify Calmèse, it also appears without the dog and apparently without any iconographical significance in the background of the lithograph of *Émilienne d'Alençon.*

It is noteworthy that in December 1897 Lautrec drew a sketch of the actor Gémier (Dortu 4,344) which was the research of his lithograph *Programme du Bénéfice Gémier* (Delteil 221). On the bottom of this sketch, Lautrec has written the name and address of Rostand.

This correlation as well as its compositional similarity to the d'Alençon print ties the portrait even more closely to the actors and actresses project and aids in the reattribution of the lithograph from *Calmèse* to *Rostand.**

On Stage, a very rare lithograph, is described by Delteil as printed in 1898 in three tones. Although all the other prints for the actors and actresses project are in one color, that does not preclude experimentation with this lithograph by Lautrec.† More important is the fact that the figure's dress, hair style, and facial features are so like the photograph of Emma Calvé, in the Opéra-Comique's production of *Sapho,* reproduced in the January 1898 issue of *Le Théâtre.* Lautrec depicted actual performers, not fantasies or personification; the figure in *On Stage* has until now been unidentified. It is apparent, however, that this lithograph is the heretofore unlocated print of *Calvé.*

We conclude that Lautrec created twenty-two lithographs in connection with the actors and actresses project.

1. *Sarah Bernhardt*	(Delteil 150)	
2. *Sybil Sanderson*	(Delteil 151)	
3. *Cleó de Mérode*	(Delteil 152)	
4. *Coquelin Aîné*	(Delteil 153)	
5, 6, 7. *Jeanne Granier*	(Delteil 154, 264, 265)	
8. *Lucien Guitry*	(Delteil 155)	
9. *Anna Held*	(Delteil 156)	

* One of the few proofs of *Rostand* (*Calmèse*) (Delteil 291) was in the Mutiaux collection with a dedication to Malfeyt.

† The Roger-Marx collection contained two proofs of this print marked "passe," the first in two tones and the second with three tones, and there is a proof in the Gerstenberg collection with a stamp verso, E. Malfeyt & Cie.

Introduction

These total eighteen subjects including the thirteen from the published album. A reference to the execution of a lithograph for each subject except Réjane, Guitry, Marsy, and Mlle. Leconte may be found within the correspondence between Lautrec and Sands. We consider it not just a coincidence that each of the nine lithographs from Lautrec's oeuvre now associated with *Treize Lithographies* was printed in a very limited run of at most twelve copies; instead, this indicates their function as trial proofs for the artist and, most important, supports our contention that they were made in preparation for the edition of 250 proposed by Sands for the ill-fated actors and actresses book.

There seems to have been no systematic process for selecting the personalities for the actors and actresses book. Rather, it appears that Lautrec collaborated with Byl to pick likely candidates based upon their personal preferences and the stimuli of photographs reproduced in theatrical publications as well as the availability of biographical information. Three of the earliest lithographs produced for the project depict Polaire, Belfort, and Held, who were essentially café-concert performers rather than actresses. Sands, in one of his last letters, rejects Byl's medallions of Belfort and Held because the singers were hardly known in London. They must have been the choice of Lautrec, who had often depicted them in the past, but not of Byl, whose usual source of biographical material, *Nos Artistes*, did not include these performers.*

The journal *Le Théâtre* and the photo albums *Le Panorama, Nos Jolies Actrices,* and *Le Panorama, Paris la Nuit* were new sources available to suggest particular performers and also types of poses for portraits.† Rostand,

* Jules Martin, *Nos Artistes, Portraits et Biographies,* Paul Ollendorff, Paris, 1895.
† See the bibliography for details of these publications.

Introduction

Coquelin, Bernhardt, Guitry, and Calvé, for instance, were prominently featured in the January and February issues of *Le Théâtre*. *Cyrano de Bergerac* had just opened at Le Théâtre de la Porte-Saint-Martin; Rostand and Coquelin were hailed as the successful author and star of this new smash hit. Bernhardt and Guitry were praised for their performances in *Les Mauvais Bergers* and Calvé for her role in *Sapho*. Photos of twenty-five of the twenty-eight personalities suggested for the project are, in fact, found in the theatrical publications of the time. There are enough similarities, as our photo comparisons reveal, to suggest that for the actors and actresses project Lautrec relied heavily on these publications. It was not, however, unusual for him to refer to photographs. There are numerous examples going back to 1888 in which the artist based his compositions upon specific photos. Indeed this was often a favored method of work for Lautrec.

Byl produced eighteen biographical sketches for the project. Five of these were several pages in length—similar to the introductory essay he prepared for the Guilbert album, for which he received 100 francs. For the remaining performers Sands requested much shorter "medallions" for a reduced fee of twenty-five francs each. After paying for thirteen, Sands requested that Byl not write or submit medallions for Held and Belfort.

The essays and the medallions were to be anecdotal, humorous, and generally laudatory, or as Sands requested for the Guilbert essay:

This article must be more on the subject of her successes—for example, that she has been singing for ? years—that she lives in an apartment in ? Street. That she is married to ? That she likes birds, cats, and things like that—that her profession is ? What type of song she likes best—particularly that she has sung at La Scala—little things like that.

None of the eighteen sketches had previously been published. Eight of Byl's medallions survive as part of the Lautrec/Sands correspondence and are published in this volume for the first time. They are d'Alençon, Polin, Hading, Marsy, Balthy, Mounet-Sully, Guitry, and de Mérode. These combine biographical information with colorful anecdotes and mean gossip. For Marsy he wrote:

Outside of the theater, she is interested in riding and has a valuable stable. She can allow herself this luxury. She earned a large sum by keeping company with a

Introduction

suitable small young man, now dead, who had 50 million. The most detested woman in Paris.

The editorial sarcasms are surely Byl's, for as we shall see he was hardly an honorable individual. In fact, in the surviving medallions for Polin, Hading, Mounet-Sully, and Guitry, much of the biographical material was drawn verbatim from the 1895 edition of *Nos Artistes*. The five long-form essays were Bernhardt, Rostand, Coquelin, Calvé, and Polaire. The thirteen medallions or short-form essays were d'Alençon, Polin, Hading, Marsy, Balthy, Mounet-Sully, Guitry, Granier, Febvre, Antoine, Réjane, Sanderson, and de Mérode.

Arthur Byl is a curious participant in this entire project. Although a writer and co-author of numerous plays and articles from 1887 to 1900, he is not listed in *Nos Auteurs et Compositeurs Dramatiques* of 1897 or other relevant directories of the time, nor may he be located in the Bottin of the city of Paris. Yet his close link with the artistic community of Paris is undeniable. One first encounters Byl in connection with André Antoine and the creation of the Théâtre-Libre in the Spring of 1887. While seeking unpublished realist plays for his projected theater, Antoine became acquainted with Byl. In his memoires, Antoine credits his new friend with participating in the naming of the avant-garde theater:

I [searched] several days for an epigraph rather than a title [for the theater]. There [was] one which would be excellent: "Le Théâtre en Liberté" borrowed from Hugo, but I do not know what troubled us; it seemed to us too romantic. And as we threw this idea around, Byl suddenly cried out, while spilling his pernod: "In that case, Le Théâtre Libre," and I felt then this was what we were truly looking for.*

The theater opened on March 30, 1887, and Byl had the distinction of being the author of two of the first pieces to be performed at the Théâtre-Libre. *Prologue en Vers* and *Un Préfet,* a one act comedy, appeared along with *La Cocarde* by Jules Vidal, *Mademoiselle Pomme* by Duranty and Paul Alexis, and *Jacques Damour* by Hennique from a novel by Zola. Antoine said, "the play by Vidal was mediocre, but the play by Byl, *Un Sous-Préfet* [*sic*] caused a scandal and was booed. . . . All in all the evening was a loss." According to Antoine, it was Byl who had introduced to him the more established author,

* André Antoine, *Mes Souvenirs sur Le Théâtre-Libre,* Arthème Fayard & Cie, Paris, 1921, pp. 23–24.

Introduction

Vidal. He in turn introduced Antoine to Paul Alexis, who brought the group in contact with their idol, Emile Zola.

After the failure of the premier performance at the Théâtre-Libre, Antoine was eager to find better material by more celebrated writers and rejected Byl's and Vidal's request to collaborate on a play for the second event of the season. The two outraged authors rebelled and threatened publicly to set up "the true Théâtre-Libre" under their own direction. Antoine wrote on June 28, 1887, "Peace is made with Byl and Vidal. Their tentative schism and competition collapsed before my activity." To appease and compensate the two for their initial contributions in the organization of the theater, Antoine agreed to allow Byl and Vidal to produce an adaptation of the Goncourt novel *Soeur Philomène* for the fall season. That next season at the theater Byl also collaborated with Oscar Métenier in an adaptation of Edgar Allan Poe's *The Fall of the House of Usher.*

Essentially Byl's tactics with Antoine had shown the former's true character. The evidence of plagiarism that one finds in his medallions for the Sands project reinforces the suggestion of dubious character. The final confirmation of his unscrupulousness, coincidentally, occurs with Yvette Guilbert in 1902. Byl had convinced Guilbert that a book by her dealing with her observations of café-concert life would be very popular. He assured her that he was not after fame but rather after pecuniary reward. Therefore he would help write it, and her name would guarantee its financial success.*

Once the book, *La Vedette,* achieved success, Byl claimed authorship and brought suit against the singer. Byl lost the case. Evidence was produced which suggested that he had not written the book—indeed, he was not even capable of doing so—and that unknown to Guilbert, but at the instigation of Byl, the real co-author was Louis Marsolleau. Marsolleau had collaborated previously with Byl. In 1890 he made his theater debut when the two created the musical drama *La Folie de Pierrot* for *La Scala,* and in 1898 they wrote *Hors les Lois,* a one-act comedy for which the cover of the published play was illustrated, interestingly enough, with a lithograph by Lautrec (Delteil 220).

In February 1899 Byl wrote the introductory essay for the catalogue of new paintings by Charles Maurin exhibited at the Edmond Sagot Gallery.†

*Bettina Knapp and Myra Chipman, *That Was Yvette, the Biography of a Great Diseuse,* Frederick Muller Limited, London, 1966, p. 199.

†Arthur Byl, introduction to the exhibition catalogue of paintings by Charles Maurin, Edmond Sagot Gallery, Paris, February 1899.

Introduction

Maurin was a close friend of Lautrec. Both artists spent much time sketching the animals at the zoo. Coincidentally, Byl's *Les Ours* of 1887 describes his own visit to that zoo. It is also worthy of note that Maurin created a poster for the spring 1898 revival of Byl's and Vidal's *Soeur Philomène.**

Our investigation of the correspondence between Lautrec and Sands reveals a fascinating interweave of personalities and relationships. The most obvious and almost consanguineous links are Lautrec/Guilbert/Byl; Byl/Antoine; Antoine/Lautrec (the artist produced three lithographic programs for the Théâtre-Libre, three lithographs depicting Antoine as an actor, and two programs for the Théâtre-Antoine; Antoine was included in the list of twenty projected portraits); Byl/Marsolleau; Lautrec/Byl/Marsolleau; Guilbert/Byl/Marsolleau. These are only some of the almost endless interconnecting relationships among artists, writers, and performers which come to light as one studies the cultural life of Paris at the end of the nineteenth century. The Lautrec/Sands correspondence significantly enriches our appreciation of this artistic interaction.

PHILLIP DENNIS CATE

* *Soeur Philomène-Théâtre Antoine.* Printed by E. Malfeyt & Company, 8 Rue Fontaine, Paris. E. Malfeyt was a printer and paper dealer located in a shop at 8 Rue Fontaine adjoining the livery stable of E. Calmèse at 10 Rue Fontaine. If one stepped out of the back door at No. 10, one would find oneself in the rear yard of 9 Rue de Douai, the apartment building where Lautrec's mother resided.

The Correspondence

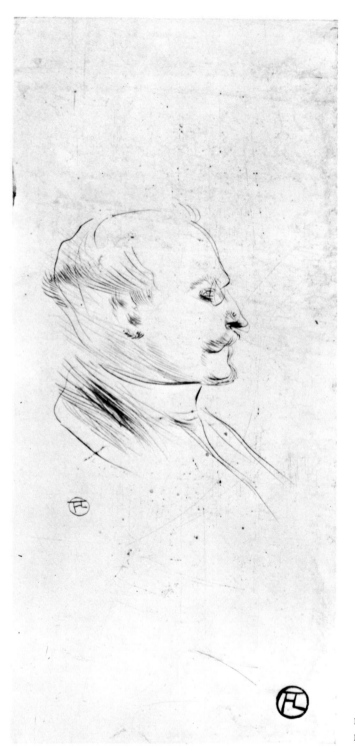

W. H. B. Sands, Editor.
DRYPOINT ETCHING, 1898.
DELTEIL 5.

1. TO W.H.B. SANDS, LONDON

[Paris, July 6, 1896]

Dear Sir:

I have learned through Spoke[1] that you have written me something about a book. I will be in Paris for 4 more days, 30 rue Fontaine. Thank you for your friendly letter and in the hope of hearing from you,

Cordially yours,

H. de T. Lautrec

P.S. Please pay my respectful compliments to Mrs. Sands.

1. Louis Bouglé, also known as Spoke, was sales manager of the company that manufactured the Simpson bicycle chain. Lautrec accompanied him to England making sketches of bicycle racers and drew the poster *La Chaîne Simpson* in June 1896. (Delteil 360 and Goldschmidt & Schimmel, London, 204). He later worked for Sands, the publisher of *The Paris Magazine*, writing "Cycling Notes" under the name "Spokes."

30 rue Fontaine. Toulouse-Lautrec moved to this address during July 1895 and lived here until 1897. (Photo H. D. Schimmel)

2. TO W.H.B. SANDS, LONDON

[Paris, June 2, 1897]

Dear Sir:

Thank you for Venus and Apollo.

I have spoken of your book to several persons who will write to you.

I am thinking a great deal of our book to be done. However, I do not think that I will be ready before Christmas. It will be good enough if we have finished by then.—I would have the best writers for that: Geffroy,[1] Descaves, Tristan Bernard, etc. We could do an English edition and a French edition.

My respects to Mrs. Sands and

Yours truly,

H. T. Lautrec

I shall perhaps be over soon.

Your HTL

1. Gustave Geffroy (1855–1926). Noted art critic and author. Lautrec illustrated his volume on Yvette Guilbert (Delteil 79–95) which was published by André Marty in 1894. He also wrote *La Vie Artistique* in eight series between 1892 and 1903 as well as the preface for Julien Sermet's *Les Courtes Joies Poésies,* Paris 1897. The cover design was drawn by Lautrec (Delteil 216).

Lucien Descaves (1861–1949). Novelist, dramatist, critic. His best novels have a back-

Gustave Geffroy.
Reproduced from Dortu.
(See bibliography.)

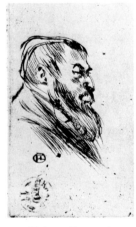

Tristan Bernard.
DRYPOINT ETCHING, 1898.
DELTEIL 9.

Lucien Descaves.
Reproduced from Dortu.

3. TO W.H.B. SANDS, LONDON

[Paris] Saturday, December 25, 1897

Dear Sir:

I have received the check for 12 pounds through Mr. Joyant[1] and thank you for it. I am thinking about the future book and will write you about it.

Yours truly,

H de Toulouse-Lautrec

1. Maurice Joyant (1864–1930). The long-time friend of Lautrec who became associated with the art dealer and publisher Goupil and Company later known as Boussod and Valadon, Boussod, Manzi and Joyant, and finally Manzi-Joyant. He arranged exhibitions of Lautrec's work both during the artist's lifetime and after his death. He also wrote the two-volume biography and catalogue published by Floury in 1926 and 1927.

Maurice Joyant.
Reproduced from Dortu.

ground of social history and were written after 1887 when he broke away from Zola and naturalism.

Tristan Bernard (1866–1947). Journalist, author, playwright. A founder of *La Revue Blanche* and director of Vélodrome Buffalo, the scene of bicycle races. Lautrec did a drypoint portrait of him in 1898 (Delteil 9) and cover illustrations for his plays *Les Pieds Nickelés* in 1895 and *La Fardeau de la Liberté* in 1897. (Delteil 128, 214).

4. TO W.H.B. SANDS, LONDON

[Paris] 15 avenue Frochot [mid-January, 1898]

Dear Sir:

I beg your pardon for writing so late, but I have been busy settling my family in Paris and I have not had any time. I think that 30 personalities are too much for your book; 20 would be better, and we would be more certain of success. For 300 copies like Polaire,[1] this will cost 33 francs to print without counting the paper.

I will take *100 francs per drawing* for myself from you. See what you would be able to give to pay the writers. Send me the figures and be assured that that will be for the best. I intend to come to London in the spring, but my friend Joyant will be coming in a few days.

—When you write to me, if you could quote the price for a small, very select exhibit room for two weeks in March or April, you *would be doing me a service*. Please present my respects to Mrs. Sands and believe me,

<div align="center">Yours truly,</div>

<div align="center">H. de T. Lautrec</div>

[Note at the top of the letter by a person in Sands's office:]

<div align="right">*15 February 1898*</div>

Better no text. Cannot use Yvette G. Say 200 or 250 at 1 or 2 guineas per copy. ?French edition suggest paying L— a royalty per copy of French edition sold.

1. *Polaire* (Delteil 227).

5. TO W.H.B. SANDS, LONDON

[Paris] January 14, 1898

Dear Sir:

I have received your proof,[1] which is very good. If you can keep the background more white and the hair of the seated lady a little less heavy, this will be better. I am sending you a Sarah Bernhardt with the text.* I believe that the text is worth 100 francs per article.

Please let me know your opinion.

Yours truly,

H. T. Lautrec

15 avenue Frochot

*By A. Byl

1. This reference is to the drawings being done for the cover design of *The Motograph Moving Picture Book*. See note 2 to letter 29.

15 avenue Frochot. After leaving 30 rue Fontaine in 1897, Toulouse-Lautrec lived and had his studio here until his death. (Photo H. D. Schimmel)

6. TO W.H.B. SANDS, LONDON

Please send me the paper samples.

<div align="right">February 25, 1898, 15 avenue Frochot, Paris</div>

Dear Sir:

Your letter is very welcome and I am sending you the list already written by my collaborator Byl to whom you are indebted for the following articles at the price agreed upon of 100 francs (100 francs each):

Sarah	Calvé	Yvette Guilbert
Coquelin	Polaire	Rostand

That is, 600 francs. He will do the other 19 in the form of medallions (short style) in the dimensions which you have indicated to him, and naturally for a proportionately lower price.—Write me about this as soon as possible. He is now ready to remove from Yvette Guilbert and the others which you have pointed out to us everything which could be harmful to the sale of the book.

I am sending you Polaire (text), and you will have those noted above as soon as there are clean copies.

I am also sending you the drawings of the following:

Sarah	Anna Held	Émilienne d'Alençon
Yvette	Polin	Granier
Polaire	May Belfort	

As for the originals, they have been done directly on stone. Each stone costs 3 francs.—

Write to me as soon as possible and believe me,

<div align="right">Cordially,</div>

<div align="right">H de Toulouse-Lautrec</div>

7. TO H. DE TOULOUSE-LAUTREC, PARIS

12 Burleigh Street, Strand,
London, Feb. 28, 1898

My dear sir:

Thank you for your letter.

I think that it will be better if Mr. Byl writes the other ones something like the following:

 Something like this—four lines.

If Mr. Byl would like to write the medallions, we could always amplify them later like the other ones.

Please tell me whether he wants me to pay him immediately or when he is finished. Now I have Sarah B. and Y.G.—I am waiting for you to return Y. in order to point out what should be removed.

You tell me, "send the paper samples." I did not understand what you would like—is this the paper on which they must be printed or the drawings which you already sent me viz. Sarah B. and Polaire? Please explain in your next letter.

I now think that you will have the 25 drawings ready to print towards the end of March—however, could you give me 6 drawings of Yvette G. immediately, that is, in two or three weeks.

I think that these drawings would be in great demand at the beginning of May when she will be here. This would be something for both of us, and also a little publicity—all the better—for you, because it will be fashionable society which will see them. Please excuse my handwriting and my French,

Cordially,

WHBS

8. TO W.H.B. SANDS, LONDON

Paris, Henry's Hotel
11, rue Volney
February 28, 1898

Dear Sir:

I have sent you a proof of Yvette Guilbert on paper which is not bad. If you have better paper, send me samples.

For Byl's payment, you will send me the check when the six articles which have been started are delivered. For the medallions, he will do them at the price of 50 francs (two pounds).

With respect to Yvette Guilbert, do you want different designs or proofs of the same one? On which paper?

Please reply as soon as possible.

Yours truly,

H. T. Lautrec

Henry's Hotel, 11 rue Volney. Formerly Hotel meublé de l'Alma. Residence until 1878 of the mistress of Robert d'Orléans, brother of the Count of Paris. Nearby at 7 rue Volney the Cercle Artistique & Littéraire exhibited the works of Toulouse-Lautrec in 1889, 1891, and 1892. In 1893 he was rejected by the group and did not exhibit at that location again. The hotel is still operating although it advertises under the name Henry's Home, 11 rue Volney, "en plein centre Opéra—calme—confort—ouvert tous les jours même dim," together with other places of similar character called studios; see *Pariscope* October 6, 1976, No. 437 p. 162. (Photo H. D. Schimmel)

9. TO H. DE TOULOUSE-LAUTREC, PARIS

Dear Sir:

Thank you for your letter.

If it is possible, I would like the 6 drawings of Yvette Guilbert from you on paper because it is almost absolutely necessary to have them printed here in London—the sale will be in two or three weeks and we must be ready to print a large quantity immediately and to have them ready at our fingertips. Can you give me 6 drawings like the one which you already sent me—it doesn't matter which ones—on paper. I am certain that they will be very successful.

Mr. Byl—I would like only 4 lines at the most or perhaps 6 for the medallions—I find that his price of 50 francs is a little high for so little. I should like to economize on the text so that I can spend more on the paper, the binding, and the advertisements, in the newspapers, the posters, etc.

You can see that for an edition of 250 copies—at 30 shillings—we will be getting up to 13/12 per copy, almost 20 shillings—that is, 25 francs. This brings 250 pounds in all. Do you think that he will do these medallions for 25 francs each? If not, I think that we will have to write several lines here in English culled from the newspapers, etc. As for the French edition, I would like to print 100 copies at 50 francs and pay you 15% as a royalty.

You understand that it is you and your drawings which are important—the text is not very necessary—and the less that we spend on the text, the more we will be able to put into the drawings.

When will you be coming to London? The weather is beautiful now! You must come to see us.

<div align="right">Very cordially,

WHBS</div>

10. TO W.H.B. SANDS, LONDON

[Paris] March 1 [1898]

Dear Sir:

I am sending you Calvé, Coquelin and Rostand. Please send me the sum of 600 francs for Byl as soon as you can. He is a very gentlemanly type and does not ask for money, but I believe he will be very glad to get it. I will send you the proofs of my drawings tomorrow or the day after.

Yours truly,

H. de Toulouse-Lautrec

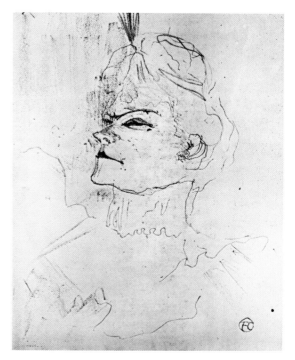

Jeanne Granier, de Profil à Gauche.
LITHOGRAPH, 1898. DELTEIL 264.

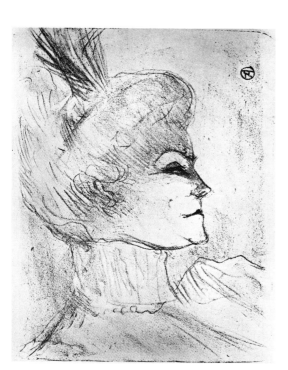

Jeanne Granier, de Profil à Droite.
LITHOGRAPH, 1898. DELTEIL 265.

11. TO W.H.B. SANDS, LONDON

[Paris] Saturday
[probably March 5, 1898]

Dear Sir:

I thank you on behalf of "Byl" for the check for 600 francs. We will have the 25 ready for the end of the month if nothing unexpected happens. I am sending you the drawings which have already been done of the following artists:

Polaire (you already have this)	1
May Belfort	2
Anna Held	3
Polin	4
Sarah Bernhardt	5
Émilienne d'Alençon	6
Granier?	
I shall do a better one[1]	7

I have yet to do the following in a final form:

Calvé
Rostand } for which Byl has done the text
Coquelin

Byl will do the medallions at the price of 25 francs.

I will send you two new drawings of Yvette tomorrow. If you wish, they will print them here on the first paper which I sent you and which

1. Lautrec probably drew *Jeanne Granier, De Profil à Gauche* (Delteil 264) and *Jeanne Granier, De Profil à Droite* (Delteil 265) before the final lithograph (Delteil 154) was chosen for publication.

is not bad. If you have better, send us the paper or let us know so they can send you the stones (as you like)—

I do not have any ideas yet about the French edition, but it would be better to print everything at the same time.—Please send the exact size of the margin which you want for the book and for Yvette.

<div align="right">Yours truly,</div>

<div align="right">H. de Toulouse Lautrec</div>

Byl suggests the following names for your selection in order to continue. Write me about this.

1. Réjane √	10. Sybil Sanderson √
2. Febvre √	11. Ackté——
3. Louise Marsy √	12. Marguerite Ugalde
4. Balthy——	13. Brasseur Jr.
5. Hading √	14. Antoine
6. Guitry——	15. Mounet-Sully √
7. Cléo de Mérode √ ——	16. Catulle Mendès √
8. Invernizzi——	17. Little Tich ?
9. Delna √	

If you see anything better, let us know.

<div align="right">Yours truly,</div>

<div align="right">H. T. L.</div>

Please send the text on Yvette so that it can be corrected.

12. TO W.H.B. SANDS, LONDON

[Paris] March 8 [1898]

Dear Sir:

I am sending you two drawings of Yvette Guilbert[1] in Pessima—and in the role of the *old grandmother*.

Yours truly,

H. T. Lautrec

1. *Yvette Guilbert, Pessima* (Delteil 254) and *Yvette Guilbert, Chanson Ancienne, 1re Planche* (Delteil 256) or *Planche Publiée* (Delteil 257).

Yvette Guilbert, Chanson Ancienne, (1re Planche).
LITHOGRAPH, 1898.
DELTEIL 256.

13. TO H. DE TOULOUSE-LAUTREC, PARIS

March 13, 1898, London

Dear Sir:

I now have 4 "Yvette's"—my idea is to make an album—how many drawings do you think will be necessary? As I have told you, 6 in my opinion—and I will return the article on her so that Byl can remove something. This article must be more on the subject of her successes—for example, that she has been singing for ? years—that she lives in an apartment in ? Street. That she is married to ? That she likes birds, cats, and things like that—that her profession is ? What type of song she likes best—particularly that she has sung at La Scala—little things like that.

In addition, I would like to have you furnish me with an "estimate."

A. How much would it cost, for paper, printing, etc., in order to print 200–250–300–350 in the same size as the drawings which you sent to me? *No binding,* that can be done here.

B. How much for the stones? This is because I also have an idea that printing a large number of smaller ones would succeed—what do you think?

C. Do you think that she would want to sign? This would be something. She will be here in London at the beginning of May, so we must launch the book in the middle of April.

If it is possible for the printing to be done in Paris, I think that the name "Goupil" will be on the binding. That company does not work in London, does it?

My devoted compliments,

W. H. B. Sands

Please write immediately if it would displease you if we print *a large*

quantity, low cost, costing 3 francs or 5 francs?—naturally, you would share in the profits beyond the cost of the stones and the drawings. I think that this is a good idea.

14. TO W.H.B. SANDS, LONDON

[Paris, March 14, 1898]
Monday

Dear Sir:

I am sending you one more Yvette Guilbert. I will answer the other questions tomorrow.

Yours truly,

H. de T. Lautrec

15. TO W.H.B. SANDS, LONDON

[Paris] March 16, 1898

Dear Sir:

The Yvette Guilbert which you suggested to me is not yet completely ready. Send me the text in order to have it arranged by Byl immediately.

The Goupil company cannot undertake to produce lithographic impressions. They do only aquatints and photoengraving. I am also sending you my printer's price for printing and paper.—

My exhibit[1] will open in Regent Street at Boussod and Valadon on May 1. I will be in London about April 20 or 23.—

I will have several more drawings to send you in 3 or 4 days—Calvé, Rostand, etc. The printer has asked a higher price for this printing because it is necessary to dampen the paper first.—

If your company can send me the fees for the drawings already delivered, you would be doing me a service, for I have a great deal to pay at this moment. Pardon me if this is indiscreet.

Yours truly,

H. T. Lautrec

15 avenue Frochot

1. "Portraits and Other Works by M. Henri de Toulouse-Lautrec" at The Goupil Gallery, 5 Regent Street, London SW. The catalogue contained 78 items. The exhibition previewed Saturday April 30, 1898, and opened by invitation on May 2, 1898.

Four paintings and one lithograph were transferred to The International Society of Sculptors, Painters, and Gravers Art Congress which also opened in London, May 1898.

The President of the Society at that time was James McNeil Whistler and the exhibition included Manet's *Execution of Maximilian* [sic], Whistler's *Rose and Silver—The Princess of the Land of Porcelain* and Degas' *Café Chantant* among 717 entries.

Lautrec mistakenly listed as F. De Toulouse Lautrec, and alphabetically under the "D's", was represented by *Jane Avril at the Entrance of the Moulin Rouge,* an otherwise unidentified portrait of Jane Avril, *Quadrille at the Moulin Rouge,* an unidentified pastel, and the color lithograph, *The Country Party.*

16. TO H. DE TOULOUSE-LAUTREC, PARIS

[London] March 18, 1898

Lautrec:

For the other book—I believe that you have already done six—you are in the process of also doing Calvé, Rostand, Coquelin, Granier; this will be Réjane, Marsy, Febvre, Hading, Delna, Sanderson, Mendès, and Sully, for sure; this will be 18 in all, and we will be able to decide about the others when you are in London.

No Signature

[W. H. B. Sands]

17. TO W.H.B. SANDS, LONDON

[Paris] Friday, March 18 [1898]

Dear Sir:

I am sending you the Yvette Guilbert which you requested.

Yours truly,

H. T. Lautrec

I have several medallions from Byl which I will send you as soon as possible.

18. TO W.H.B. SANDS, LONDON

[Paris] March 20 [1898]

Dear Sir:

Thank you for your check for 500 francs. You should have received one more Yvette. That makes 6. I will make two more as you request. At the same time I am sending you the following medallions by Byl:

Balthy	Émilienne d'Alençon*
Mounet-Sully	Jane Hading*
M. L. Marsy	Polin*

I have put an asterisk next to those which have already been drawn. I have likewise finished Constant Coquelin for which you have the text. I will have the stones for Yvette sent to you tomorrow morning, Monday. The price of each stone is 2.50 or 3 francs according to the proof. The account for this will be payable as a sum total at the end.—

For the French edition, please write to Floury[1] in order to establish the conditions. I think that he will go along. If not, I will find something else.

Yours truly,

H. de Toulouse Lautrec

Byl is furnishing Yvette Guilbert. He will send you two different ar-

1. Henri Floury, Éditeur, of 1 Boulevard Des Capucines, Paris, had a long association with Lautrec. He published Georges Clemenceau's *Au Pied du Sinai* which was printed April 20, 1898, and was illustrated by Lautrec (Delteil 235–249, 320). In 1899 he published Jules Renard's *Histoires Naturelles,* also illustrated by Lautrec (Delteil 297–319) and printed by Henry Stern. In 1926 and 1927 he published Joyant's two-volume biography and catalogue of Lautrec.

ticles, one critical and the other flattering; you will be able to choose.

<div align="center">

HTL

March 20

</div>

P.S. For the stones, there will also be the expenses of the trials to be paid. I will write to you about the above.

19. TO W.H.B. SANDS, LONDON

<div align="right">

[Paris] March 21, 1898

</div>

Dear Mr. Sands:

I changed the Yvette Guilbert biography along the lines you indicated. The second version contains four new pages which will be tied into the fifth and following pages of the first version. I believe that in this way, Yvette will be happy to give you her signature. If she does not agree, you could make use of the first version which is more complete and more amusing—there are some humorous details never before published which might amuse your clients. Nothing more intimate or more complex has been done on Yvette Guilbert. In the final analysis, the choice is up to you.

Thank you and best regards.

<div align="right">

Arthur Byl

</div>

20. TO W.H.B. SANDS, LONDON

[Paris] March 22 [1898]

Dear Sir:

Today I am sending you Byl's text and you must have received the six stones. I have made another one.

Yours truly,

H. T. Lautrec

[Note at the top in a different hand (probaby W. H. B. Sands):]

[London] March 24, [1898]

I have received six stones this morning. I am waiting for two more. I paid 20–0–6 for these six stones. Can you give me "an a/c" for everything, that is, the drawings already done. I believe that these 20–0–6 are for the other drawings, because you have told me "to pay for the stones as a whole at the end."

21. TO H. DE TOULOUSE-LAUTREC, PARIS

[London] March 25, 1898

Dear Sir:

Balthy is not in my list of eighteen drawings—since Byl has done Balthy, we will have to substitute it for Delna—and I think that we will also have to have Ackté instead of Catulle Mendès—and also, in order to have 20, Antoine and Guitry. What do you think?

In great haste.

Yours truly,

W. H. B. Sands

22. TO W.H.B. SANDS, LONDON

[Paris] Sunday, March 27 [1898]

Dear Sir:

In accordance with your letter, we will do Balthy instead of Delna. That's all right, isn't it.—

Send me in duplicate the list of articles which Byl has delivered, for even though I keep the books well, I am always afraid of making a mistake. Once again, do you prefer Sybil Sanderson or Ackté?—

I am sending you the text for Guitry today and the form of wording for received on account. Is an invoice stamp necessary, or is this sufficient. — ? —

The other two stones of Yvette are ready. I will send them tomorrow——Monday. I will provide a separate accounting as a whole for the price of the stones and the proofs.—cordially.

Yours truly,

H. de Toulouse Lautrec

23. TO W.H.B. SANDS, LONDON

[Paris] March 27, 1898

Received the sum of 600 francs from Mrs. Sands for 6 drawings of Yvette Guilbert on stone.

There remain two drawings to be done which have not been delivered at the same price, that is, 100 francs each.

H. de Toulouse Lautrec

15 avenue Frochot

24. TO H. DE TOULOUSE-LAUTREC, PARIS

[London] March 28, 1898

Dear Sir:

Thank you for your letter.
The list should include

1. Bernhardt		13. Ackté	
2. Rostand		14. Held	
3. Coquelin		15. Granier	
4. Calvé		16. Febvre	
5. Polaire		17. Antoine	
6. d'Alençon	articles already done	18. Réjane	
7. Polin		19. Sanderson	
8. Hading		20. Belfort	
9. Marsy			
10. Balthy			
11. Mounet-Sully			
12. Guitry			

WHBS

25. TO W.H.B. SANDS, LONDON

[Paris] April 1 [1898]

Dear Sir:

Enclosed I am sending you the note on the stones for Y. Guilbert, the preparatory proofs, and the stones plus packing.

I have made a separate accounting, for I do not know whether you want to have the other 20 drawings printed here or in London which then means that you again owe me personally for 3 Yvette's at 100 francs, that is, 300 francs. Tell me since I have to pay the printer immediately.—

Instead of Ackté, I have done Cléo de Mérode. The subject is more sympathetic. Monday or else Tuesday you will have the proofs of the Cléo and Sybil Sanderson. I have divided the two accounts in order to avoid confusion. I will go to see Yvette myself for her signature.

Yours truly,

H. de T. Lautrec

26. TO W.H.B. SANDS, LONDON

Proofs and preparation of 8 stones (Yvette Guilbert drawings)	40.00
Value of the 8 stones at 2 francs, 40 centimes each	19.20
First packing case	3.90
Second packing case	1.60
	64.70

[Paris] April 1, 1898

Henry Stern

27. TO W.H.B. SANDS, LONDON

[Paris, April 4, 1898]

Dear Sir:

I am sending you the drawings of Cléo de Mérode and Sybil Sanderson.

Yours truly,

H. T. Lautrec

28. TO W.H.B. SANDS, LONDON

[Paris, early April 1898]

I send you back the copy with the *Erasures* of Yvette herself and the medallion of Sybil Sanderson.[1]

Yours truly,

H. T. Lautrec

1. A postal card written by Lautrec to Sands dated Paris April 7, 1898 reads as follows: "The titles of the Yvette prints I have put on the stones but they have probably rubbed out. Send me the proofs and you will have them all by return mail." (Courtesy Elliott Galleries, New York City.)

29. TO W.H.B. SANDS, LONDON

Pavillon d'Armenonville[1]
[Paris] Thursday, April 7, 1898

Dear Sir:

I have received your check of Saturday for 500 francs and thank you. I have thereby received from you *600* francs for Byl, *500* once for myself, and *500* francs another time for myself (1600 francs in all); this means 8 drawings of Yvette paid for and 200 francs in advance on the book *(from these two hundred francs, I have taken 65 francs for the stones,*

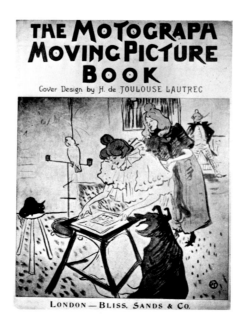

The Motograph Moving Picture Book. Cover, 1898.

1. The Pavillon d'Armenonville is a restaurant in the Bois de Boulogne east of the main entrance of the Jardin d'Acclimatation—as described by Karl Baedeker in his edition of *Paris and environs*, Leipzig, 1900: "Restaurant of the highest class, pleasantly situated."

proofs, and wrapping to Stern); this therefore means 135 francs for the account of our 20 medallions a portion for the drawings. I am mentioning this detail for you in order not to confuse the two matters. Please send me the text for Yvette so that Byl can retouch it if it is necessary according to your directions. As for the cover, how do you want it? In lithograph or by the same process as that for the Nursery Toy Book.[2] In black or in color? I will see Yvette at once for her signature. Will a single autograph signature be sufficient?

<div style="text-align:center">Yours truly,</div>

<div style="text-align:center">H. de Toulouse Lautrec</div>

P.S. Telegraph me instructions for the cover.

<div style="text-align:center">H. T. L.</div>

Return the Sybil Sanderson text to me. Byl has a better one. I will send you the medallion for Cléo Mérode.

2. *The Motograph Moving Picture Book,* published by Bliss, Sands & Co., 12 Burleigh Street, Strand, W.C., London, 1898, with cover design specially drawn for the book by H. de Toulouse-Lautrec and illustrations by F. J. Vernay, Yorick, etc. This is a children's toy book, in which a special transparency is to be moved slowly over the illustrations to give the illusion of moving pictures. It was printed in a French version entitled *Le Motographe Album D'Images Animées* by Clark & Cie., 225 Rue St. Honoré, Paris, 1899, using the same cover and illustrations as the earlier English edition.

The study for the cover design is illustrated in Dortu (D4,442) together with two photographs of the drawing touched up with ink and watercolor (D4,443, D4,444), which were probably used as research for the colors to be used. Dortu incorrectly dates these 1899 together with D4,561 and D4,577, studies for the parrot in the drawing. Other drawings—*A Parrot on a Perch* (D4,385) and the *Heads of Parrots* (D4,386, D4,413), dated 1898—are probably additional studies for the cover although Dortu does not say. The study for the cover design was originally in the collection of W.H.B. Sands. In June 1914 it was exhibited at Galerie Manzi, Joyant in Paris, number 147 from Collection de M.S. . . . (Sands). It was also in the collection of Maurice Joyant and M. G. Dortu.

30. TO W.H.B. SANDS, LONDON

Paris, April 10, 1898

Please give me the address of Henri Perrin and Co. I do not know it. Letter follows.

Yours truly,

H. T. Lautrec

[Note at the top also by Lautrec:]

Stone cannot leave until Wednesday morning. Impossible before this.

31. TO W.H.B. SANDS, LONDON

[Paris] Sunday [April 10, 1898]

Dear Sir:

An hour ago, I sent you a note to tell you that I did not know Henri Perin. I finally found on my notes Hernu Péron.[1] As the company has not told me anything further, I will go Tuesday and I will write you tomorrow on the other questions in your letter of today. Best to you.

Yours truly,

H de Toulouse Lautrec

1. Hernu Péron, an international import-export transportation company, was formed in 1802. After using various names, in 1882 it took the name A. Henry & Cie. which it retained until 1890 when the for the first time it was called Hernu Péron & Cie. after two of the principal partners, Albert Hernu and Charles Péron. In 1894 it became an English company with offices in numerous places including London and Paris. It remained associated with the English until 1935, when the English branch was taken over by British Railways and the French branch became Hernu Péron, as it exists today with three offices in Paris.

32. TO W.H.B. SANDS, LONDON

Paris, April 13, [18]98

Dear Sir:

I am sending the proofs of Yvette back to you. My cover is not finished.
I have not had time to go to see Hernu and Péron. I will write you to-
morrow.

Yours truly,

H. T. Lautrec

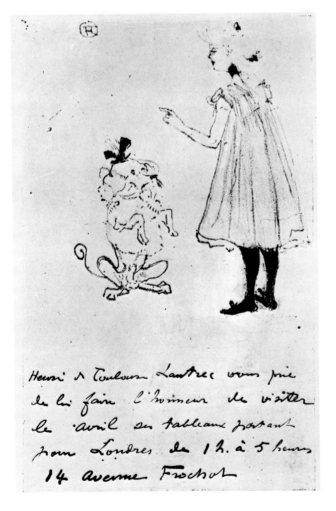

Invitation à une Exposition. LITHO-
GRAPH, 1898. DELTEIL 232. Before
sending his pictures to Goupil Gal-
lery in London, Toulouse-Lautrec in-
vited some friends to 15 avenue
Frochot for a preview.

33. TO W.H.B. SANDS, LONDON

[Paris] Saturday [probably April 16, 1898]

Dear Sir:

I finally have the 500 francs from Hernu and Péron. They had sent it to my home and did not find me. Thus I have received from you the following:

500 francs
500 francs
500 francs, that is, 1500 francs and Byl 600 francs—

Today Byl is going to deliver to me the remaining medallions from the list of March 28. I have seen Yvette Guilbert, who will arrive in London in a few days. Her debut will be on May 2, the day my exhibit opens. I will arrive in London on Monday, April 25, and we will talk. Yvette told me that she will sign whatever is wanted. Do you want her to sign on autograph paper for the current edition and you will make a transfer. I have sent you the cover. It is good. I have left space for the letter in white.

Please reply to me and tell me if you can send me the proofs of Byl's text in order to show them to Yvette.

Yours truly,

H. de Toulouse-Lautrec

34. TO W.H.B. SANDS, LONDON

[Paris] Sunday [probably April 24, 1898]

Dear Sir:

I am sending you Byl's last medallions. I regret that the cover could not be used. I will have Yvette sign an autograph paper today and you will need only to have it transferred to stone. I will also sign in the same way.

Yours truly,

H. T. Lautrec

35. TO [W.H.B. SANDS, LONDON]

[London, April 30, 1898]

Goupil Gallery
5 Regent Street

Henri de Toulouse-Lautrec[1]

Saturday 30

1. Toulouse-Latrec's calling card, with the gallery, address, and date in Lautrec's handwriting. This card was among Sands's possessions and was to be used as a pass to the exhibition preview.

36. TO ARTHUR BYL, PARIS

[London] May 1, 1898

Mr. Byl

Dear Mr. Byl:

Mr. Lautrec told me that he has given you 100 francs for 4 medallions. There are then 9 remaining for payment and I am sending you a check for 225 francs. For the present, I have enough medallions, because I have not yet decided about the other drawings. Therefore, I would not need other medallions at present. I will write to you about this later.

Please, Sir, be assured of my most respectful sentiments.

W. H. B. Sands

37. TO [W.H.B. SANDS, LONDON]

[London, May 2, 1898]

Goupil Gallery
5 Regent Street

Henri de Toulouse-Lautrec[1]
admit two

Monday 2

1. Toulouse-Lautrec's calling card with gallery, address, date, and admission in Lautrec's handwriting. This card and two similar cards were among Sands's possessions and were to be used as a pass to the exhibition opening.

38. TO H. DE TOULOUSE-LAUTREC

At 317, Charing Cross Hotel,[1] London

Karlsbad, May 6, [18]98

Dear Sir:

We are in Carlsbad! The lady had such pains that the doctors made her leave Paris immediately!

I have had to postpone my season in London until next year, my dear husband preferring that I take care of myself at once! So much for that! Friendly greetings,

Yvette (Guilbert)

1. Charing Cross Station, gateway to Paris, was opened in 1864; the French Renaissance style Charing Cross Hotel opened the following year. Lautrec often stayed at the hotel, just a short walk on the Strand from the offices of W. H. B. Sands on Burleigh Street.

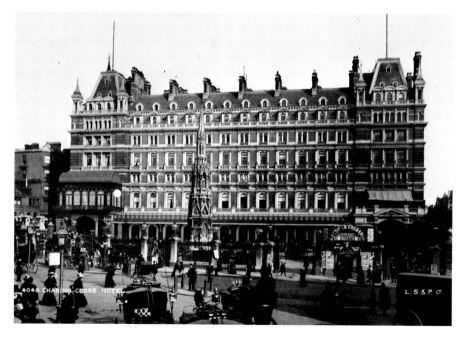

The Charing Cross Hotel, London, c. 1900. (Photo The Bettmann Archive/BBC Hulton)

39. TO W.H.B. SANDS, LONDON

[Paris] May 11, 1898

Dear Sir:

I am sending you two lithographs, Horse and Dog.[1] Could you show them to Mr. Brown[2] and ask him if, with these proofs *hand-colored* there, or others in the same style, it would be possible to do something and on what terms. I would prefer a limited edition on very beautiful paper, each proof between two and four pounds—half and half, that is, with 50% discount. Please send me a word, and many friendly greetings.

Yours truly,

H. T. Lautrec

1. The editors believe Lautrec is referring to *Le Cheval et le Colley* (Delteil 283). Other possibilities are *Le Cheval et le Colley* (*2ᵉPlanche*) (Delteil 288) or *Le Cheval et le Chien à la Pipe* (Delteil 289).
2. Reference may be to Ernest Brown, London art dealer, first with the Fine Art Society and then with Ernest Brown and Phillips, who in 1930 re-issued the Sands *Yvette Guilbert* Series, donating the stones, upon completion, to the Lautrec Museum in Albi, France.

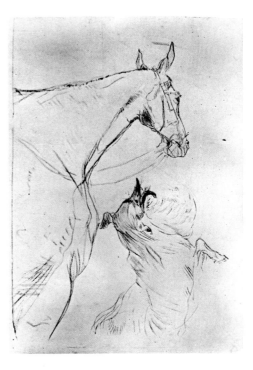

Le Cheval et le Colley.
LITHOGRAPH, 1898.
DELTEIL 283.

40. TO W.H.B. SANDS, LONDON

Paris, May 20 [18]98

Dear Sir:

Have you received the two drawings of the horses? I would be much obliged if you would tell me as soon as possible, because I'm going to leave for the country.

Yours truly,

H. T. Lautrec

41. TO W.H.B. SANDS, LONDON

[Paris] May 30 [1898]

Dear Sir:

I would be very obliged if you could tell me whether you have received all of the stones (15) and the last 4 proofs. I am leaving for the sea and have to put everything in order here. Please send me a word, and

Yours truly,

H. de T. Lautrec

42. TO H. DE TOULOUSE-LAUTREC, PARIS

[London] May 31, 1898

Check for 300 francs enclosed

Dear Sir:

I have received 4 stones.

Balthy I am afraid will be no use, so I am returning it to MM Stern. I think that MM Stern must have made a mistake in charging 5 fr. each for 15 tirages. I am writing to them on the matter.

On May 1st I wrote to Byl that I did not require any more medallions for the present, so I shall not be able to use the two on Held & Belfort. I wrote him this very distinctly, so I cannot understand why he has done or is doing any more. Belfort is quite unknown here, except to a few, all about Held that is necessary I can write myself.

I now have 14 drawings which will be enough for the moment. We can arrange for some others in the fall.

[No Signature W. H. B. Sands]

43. TO W.H.B. SANDS, LONDON

<div align="right">Paris, June 7 [18]98</div>

Dear Sir:

Keep Balthy for the present. So much the better if you can publish it. Write me about this.

<div align="right">Yours truly,

H. T. Lautrec</div>

44. TO W.H.B. SANDS, LONDON

[Paris] June 14 [18]98

Dear Sirs:

Mr. de Toulouse Lautrec asked me to write to you in order to justify the price which you find too high for the 15 stones which I sent to you last May 25th.

I am sure that anyone else would have asked you for 6 francs per stone instead of 5 francs. All of the stones were prepared twice, cleaned, and double-wrapped.

Believe me, dear sirs, that I am not attempting to make you pay more than my clients, for I work a great deal less expensively than my colleagues, and in asking for 75 francs for 15 stones with drawings, I do not think that there is anything to be said against that.

In the hope of hearing from you, believe me, dear sirs, your devoted,

Henry Stern
83 faubourg St. Denis
Paris

[Note by person in Sands's office:]

Send corrected inv. only ordered 14 stones *June 18/98*

45. TO W.H.B. SANDS, LONDON

[Paris, October 28, 1899]

Dear Sir:

Here is the letter in question as you wished. All is going well and I hope to hear from you soon. We are working again[1] and I have a book of 20 to 25 color plates about the circus which is going to be published by Joyant Manzi and Co.

Yours truly,

H. de T. Lautrec

1. The story of Lautrec's breakdown and confinement in Dr. Sémélaigne's Institution, 16 Avenue de Madrid, Neuilly, has been often told, then documented in Goldschmidt and Schimmel, London, Letters 223–230, 238–272. It was during this stay that Lautrec started the series of circus drawings, the first twenty-two of them being published in 1905, in an album with notes by Arsène Alexandre entitled *Toulouse-Lautrec au Cirque: Vingt-Deux Dessins aux Crayons de Couleur,* Goupil & Cie, Manzi Joyant & Cie, Editeurs, Imprimeurs, Successeurs.

46. TO W.H.B. SANDS, LONDON

[Paris] October 28, 1899

I declare by these presents that I have sold to Mr. Sands, publisher in London, the portrait of Polaire[1] which was reproduced in the Paris Magazine and this drawing therefore belongs to Mr. Sands with all rights.

Henri de Toulouse Lautrec
15 avenue Frochot, Paris

1. *Polaire* (Delteil 227) was reproduced in *Paris Magazine,* London, December 1898.

47. TO W.H.B. SANDS, LONDON

[Paris] February 3, 1900

Dear Sir:

I think that we could hardly ask for better than the Daily Mail[1] has done.

I shake your hand very cordially and thank you for your support in this affair.

Yours truly,

H. T. Lautrec

P.S. In addition, they have promised an article of correction. Please send it to me.

Yours,

H. T. L.

1. The *Daily Mail,* established in 1896, was a popular newspaper often referred to as part of the Yellow Press. According to Holbrook Jackson in his volume *The Eighteen Nineties* its sensationalism openly fanned the Jingo flames that led to the Boer War. In July of 1900 Arthur Symons (1865–1945), the English critic, editor, and poet, wrote: "To be quite frank, I fear it would do a lot of harm to my reputation if I were to write for the *'Daily Mail'* and I am obliged, if only as a matter of business, to think about that."

THE PHOTOGRAPHS of the actors and actresses reproduced in this volume have been chosen by the editors because they were, most likely, the sources used by Lautrec when making his lithographs. The photographs were originally taken in or near the period of the correspondence and would have been conveniently available to the artist. That some of them could be found at this late date only in the form of periodical reproduction will explain the less-than-perfect reproduction of them here.

Treize Lithographies

PAR H. DE TOULOUSE-LAUTREC

[no publisher, no place, no date]

AND

Yvette Guilbert

DRAWN BY H. DE TOULOUSE-LAUTREC

Described by Arthur Byl

Bliss, Sands & Co., London, 1898

NOTE: Not all the biographies written by Arthur Byl and submitted to W.H.B. Sands have turned up among Sands' papers. Those that have are published here for the first time and appear on the following pages in roman type. For the missing pieces, brief biographies are supplied, printed in italic type. They were prepared by the editors of this book, using the same source material available to Byl; the information furnished is for the time up to the early months of 1898.

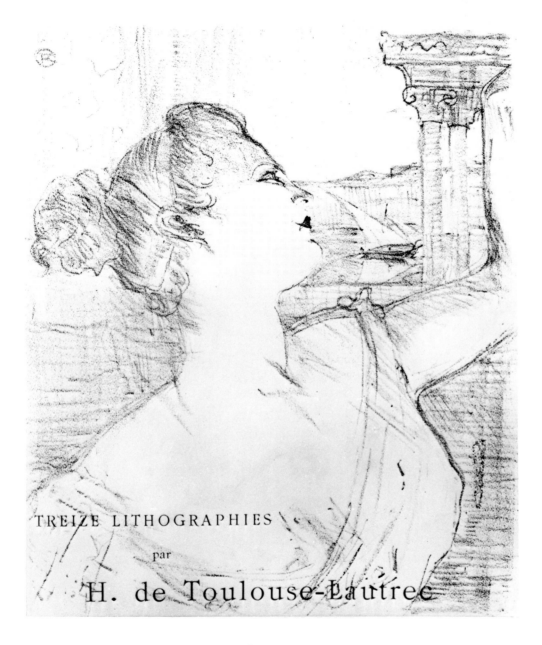

TREIZE LITHOGRAPHIES

par

H. de Toulouse-Lautrec

Cover
The publisher used each of the thirteen lithographs for
the album cover as a variant which was included as an
additional print in the complete sets.

SARAH BERNHARDT

Born in Paris, October 22, 1844. Studied in a convent near Versailles, then the Conservatory, winning prizes in Tragedy ('61), Comedy ('62). Debut at Comédie Française in Iphigénie *('62), at Odéon ('64). Played* Phèdre, King Lear, *etc. Back to Comédie Française ('72) playing* Ruy Blas, Hernani, *etc. Visited America ('80–'81), Russia ('81). In Paris played* Lady of Camelias *('83),* Tosca *('87),* Cleopatra *('90),* Lorenzaccio *('96), and* Mauvais Bergers, *which opened December 15, 1897.*

Sarah Bernhardt. (detail) in *Les Mauvais Bergers*. Reproduced from *Le Théâtre* No. 1, January 1898.

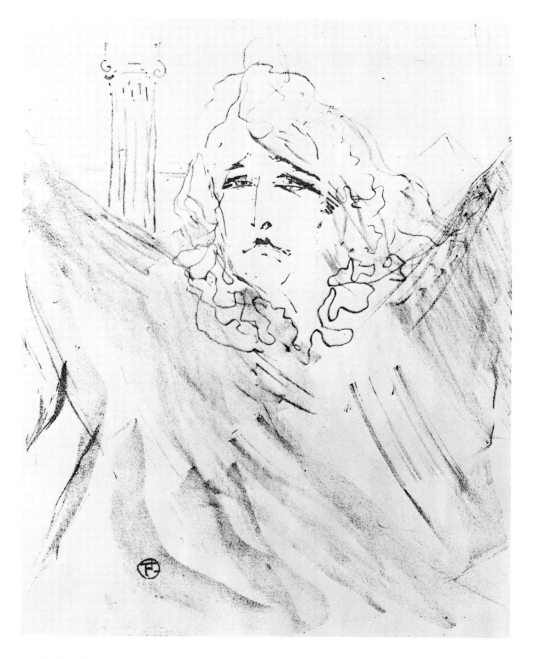

Sarah Bernhardt. LITHOGRAPH, 1898. DELTEIL 150. Adhémar thought this could be a portrait of Loie Fuller.

SYBIL SANDERSON

Born in Sacramento, California, December 7, 1865. Studied music in Paris with Sbriglia, Mangin, and Marchesi. Debut at Opéra-Comique in Esclarmonde *('89), then* Manon, Thaïs *('94), and Gilda in* Rigoletto.

Sybil Sanderson. Reproduced from *Le Panorama: Nos Jolies Actrices* No. 4, 1896-1897.

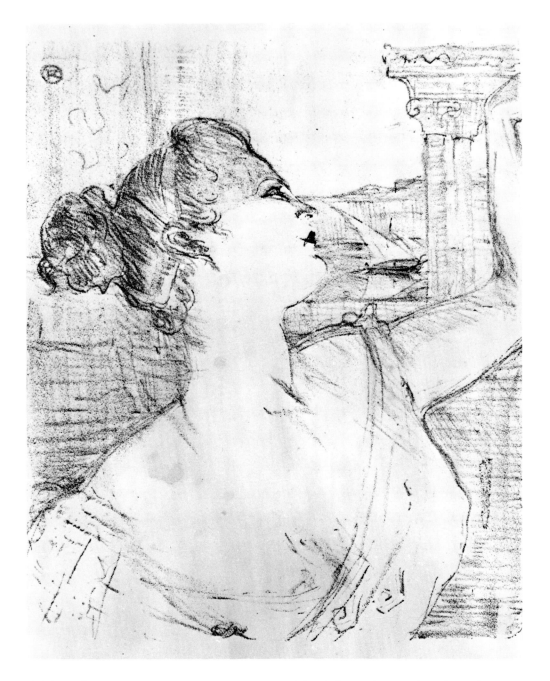

Sybil Sanderson. LITHOGRAPH, 1898. DELTEIL 151. This lithograph was thought to be possibly the portrait, *Subra, de l'Opéra,* by Delteil, Adhémar, Huisman-Dortu, and Adriani-Wittrock.

CLÉO DE MÉRODE

Miss Cléo de Mérode has been made the heroine of a multitude of stories about sleeping on her feet. Not one of them is authentic. Yes, yes, it is certain that a royal spectator, very enthusiastic, asked her to leave Paris for Brussels; however, everything is limited entirely to that.[1]

Although Miss de Mérode is known for all her physical attributes thanks specially to the statue by the master sculptor Falguière[2] which revealed her to us in a personification of the dance where she showed that she had nothing to hide, it is not the same with her intimate life.

Almost nothing is known about her. She was born in Belgium, that is sure. Where? That is the problem. She admits to being 23 years old;[3] let us believe her. According to this, she would have entered the dancing class at the Paris Opéra at the age of eight. For three years she has been a subject, that is, a dancer of the first rank. She is very modest in spite of the fuss made about her, a very good comrade, and she is adored in the theatre.

Special characteristics: she is always escorted by her mother, who is a real baronness, it seems.[4] Anything is possible.

1. A rumor constantly arose that de Mérode was having a love affair with Leopold of the Belgians; this was not true.
2. The Falguière sculpture was a full-length figure of a beautiful, nude de Mérode in an almost erotic pose. The sculptor said de Mérode posed for the head only.
3. When she died on October 17, 1966, *The New York Times* gave her age as 91, making her 23 in 1898.
4. Born in 1850, her mother was Baronne de Mérode and Marquise de Trélon.

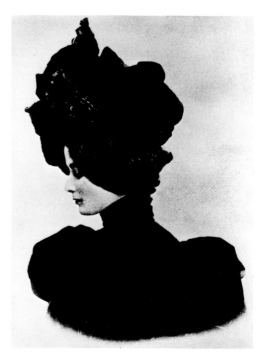

Cléo de Mérode. Unknown source, c. 1898.

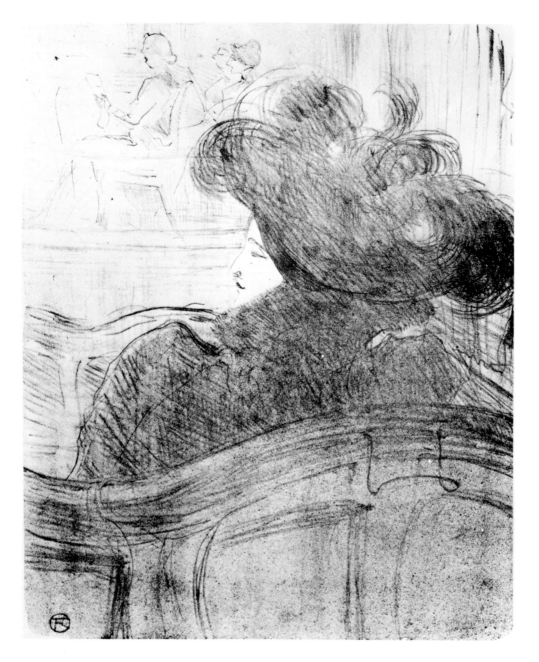

Cléo de Mérode. LITHOGRAPH, 1898. DELTEIL 152.

BENOIT-CONSTANT COQUELIN AÎNÉ

Born in Boulogne-s-Mer January 25, 1841. Studied at the Conservatory. Debut at Comédie Française ('60). From 1860–1886 did 44 roles. Visited America ('88–'89). In Thermidor *('91), tour of Europe ('92), America ('93). Created numerous roles in 1890s, including* Cyrano de Bergerac, *which opened December 28, 1897.*

Coquelin aîné (detail) as Cyrano de
Bergerac. Reproduced from
Le Théâtre No. 4, January, 1898.

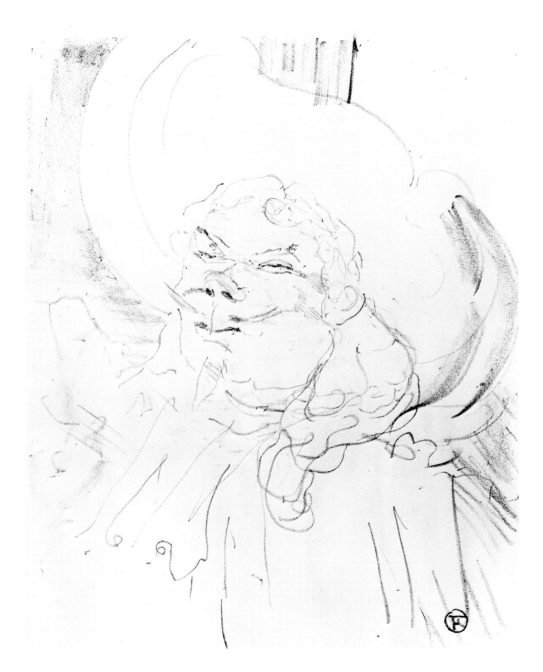

Coquelin aíné. LITHOGRAPH, 1898. DELTEIL 153.

JEANNE GRANIER

Born in Paris 1852. Student of Barthe-Banderali. Debut in 1874. Appeared over years at Renaissance, Gymnase, Variétés, Bouffes, Nouveautés, Gaité, and Eden in such plays as Orpheus in the Underworld, Bluebeard, The Grand Duchess, La Belle Hélène, La Vie Parisienne, Madame Satan, La Périchole, *and* Le Nouveau Jeu, *which opened February 8, 1898.*

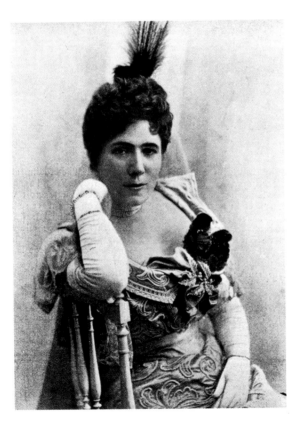

Jeanne Granier in *Le Nouveau Jeu.*
Reproduced from *Le Théâtre* No. 3,
March, 1898.

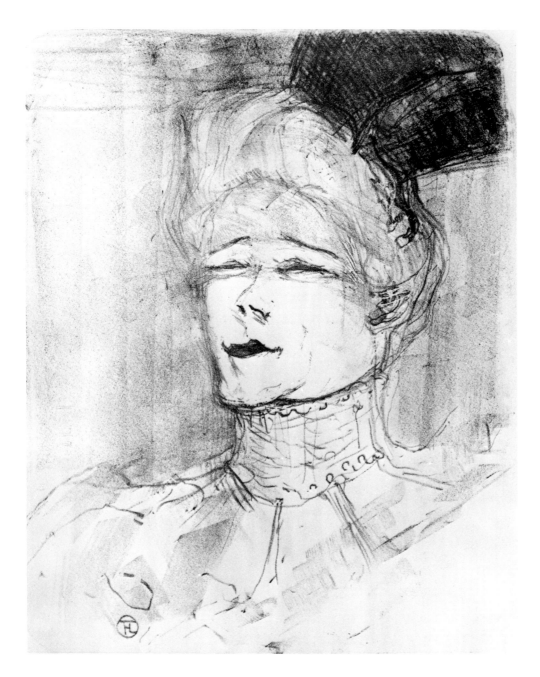

Jeanne Granier. LITHOGRAPH, 1898. DELTEIL 154.

GUITRY

Lucien Germain Guitry was born in Paris on December 13, 1860. He entered
Monrose's class in the conservatory in 1876 and left in 1878 with a second prize
in comedy and a second prize in tragedy. Debut at the Gymnase in the *Dame
aux Camélias* in the role of Armand Duval on October 1, 1878. He created
L'Âge Ingrat in 1878 and the *Fils de Coralie* in 1880. Left the Gymnase in 1881.
Spent several years in Russia where he played the entire French repertory. Was
obliged to leave St. Petersburg after an altercation followed by a fist fight with
the Grand Duke Vladimir, the brother of the Emperor. His Imperial Highness
had puffed eyes, and the comedian got away with several bruises and an order
to leave Russia within 24 hours.[1]

Guitry entered the Odéon in 1891; he revived the *Amoureuse* and *Kean*
there. He went to the Grand Théâtre in 1892 and created *Lysistrata* and the
Pêcheur d'Islande. From there he went to the Renaissance where he played in
Les Rois, Izail, Gismonda, Amphitrion, and last of all, *Les Mauvais Bergers*
by Octave Mirbeau.

1. The story goes that Guitry was dining in St. Petersburg in a private room at The
Bear, with his leading lady, when the Grand Duke Vladimir accompanied by his wife
broke in. The Duke made outrageous sexual advances toward the lady, which Guitry put
a stop to by making equally outrageous advances to the Grand Duchess.

Lucien Guitry. Reproduced from
Nos Artistes, 1895.

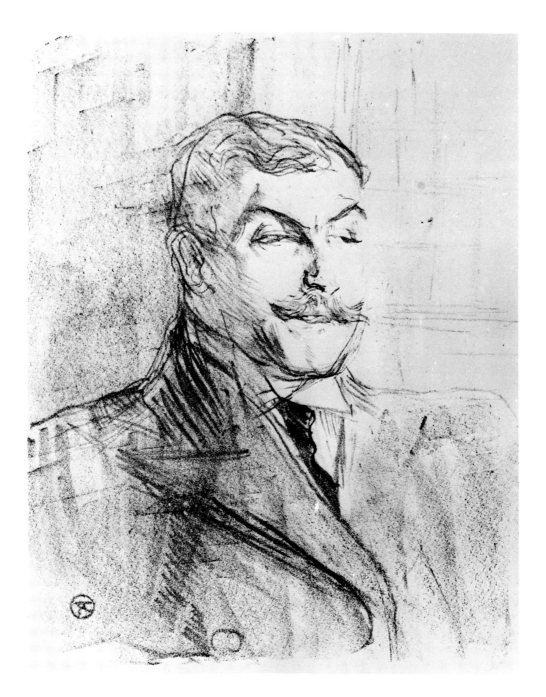

Lucien Guitry. LITHOGRAPH, 1898. DELTEIL 155.

ANNA HELD

Born in Warsaw, she made her Paris debut in La Vie Parisienne *('94). She appeared at La Scala ('95), visited New York in October ('97), and toured the South and West in America in early '98.*

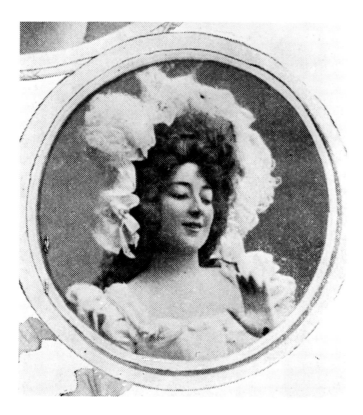

Anna Held. Reproduced from *Le Panorama: Paris la Nuit*, c. 1898.

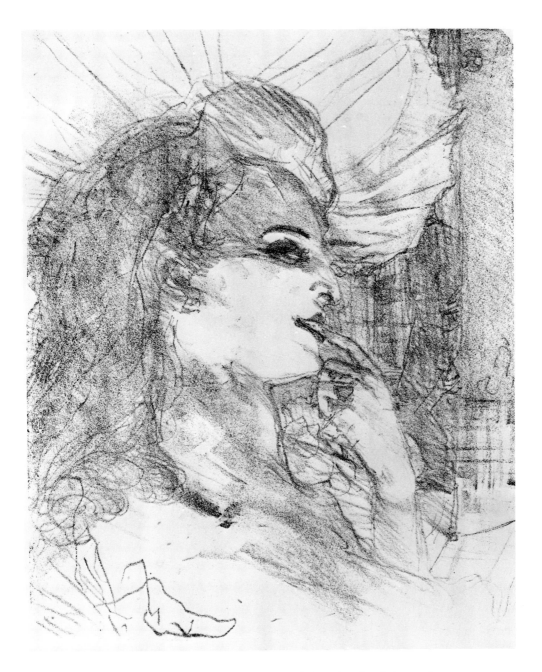

Anna Held, LITHOGRAPH, 1898. DELTEIL 156. Delteil thought this lithograph was possibly a portrait of Marcelle Lender, Adhémar thought it was Jane Hading, Huisman-Dortu identified it as an unknown actress, and Adriani-Wittrock thought it was either Lender or Hading.

BALTHY

She was born in Bayonne in 1867 to poor weavers who already had 12 children.

She was employed in a funeral home at a salary of 40 francs per month. Debut at the *Eldorado* without success. Subsequently went to *La Scala* at 90 francs per month. From there she went to the *Palais Royal* as an extra and remained there for three years. Finally found her path at the *Menus Plaisirs* where she was a triumph.

Very whimsical, somewhat boyish. Skinny, rather homely. Has a stomach ailment. Assures the existence of some 15 relatives: brothers, nephews, etc.

Has a very pretty voice, knows how to use it with skill. After a stay at the Variétés, she devoted herself to creating short revues which she plays at the Bodinière and particularly in fashionable salons with her comrade, Fordyce, the author and actor.

1. *Nos Artistes* reported in 1895 that Balthy was born in 1869.

Louise Balthy.
Reproduced from *Nos Artistes*, 1895.

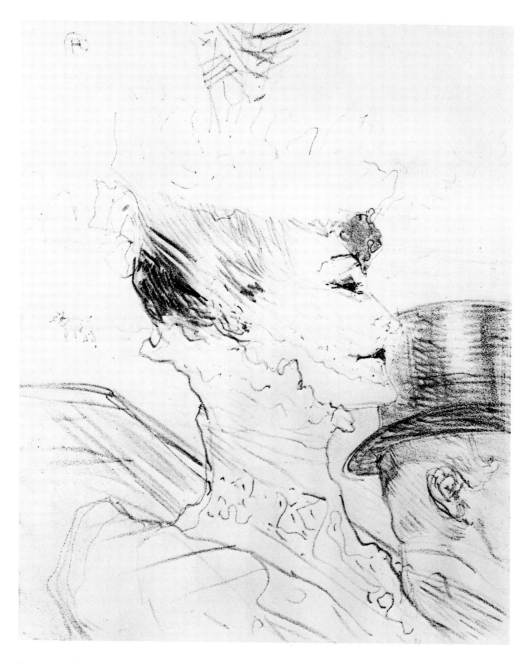

Louise Balthy. LITHOGRAPH, 1898. DELTEIL 157. This lithograph was thought by Delteil and Adriani-Wittrock to be possibly a portrait of Yvette Guilbert, Adhémar thought it was Yvette Guilbert or Marcelle Lender, and Huisman-Dortu identified it as *Femme en Fiacre.*

M. L. MARSY

Her real name is Anne-Marie-Louise-Joséphine Brochard. Born in Paris on March 20, 1866. First prize for comedy at the Conservatory in 1883, Mr. Delaunay's class. Debut at the Comédie Française in the *Misanthrope,* December 22, 1883. Subsequently played in the *Marriage of Figaro.* Left the theater in 1886. Returned in 1888 in order to create *La Grande Marinière* at the Porte-Saint-Martin. Returned to the Comédie Française in 1890. Was named a member of the company in 1891.

Outside of the theater, she is interested in riding and has a valuable stable. She can allow herself this luxury. She earned a large sum by keeping company with a suitable small young man, now dead, who had 50 million.[1]

The most detested woman in Paris.

1. The immensely wealthy Max Lebaudy died in December 1895 at the age of 23. His unusual death while in the French Army, together with charges of extortion and blackmail, was one of the great scandals of the period, filling both the newspapers and the courtrooms. Lautrec drew a lithograph in 1896 of Mlle. Marsy testifying at the Lebaudy Trial (Delteil 194).

Dortu states that Lautrec did seven sketches of Marsy at that time (Dortu 4051, 4052, 4054, 4089, 4090, 4091, 4237). The facial characteristics in the sketches are varied.

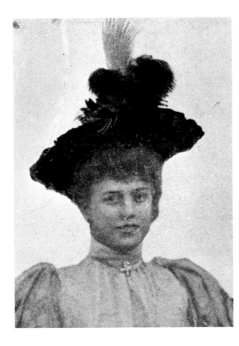

Marie-Louise Marsy. Reproduced from *Le Panorama: Nos Jolies Actrices* No. 5, 1896-1897.

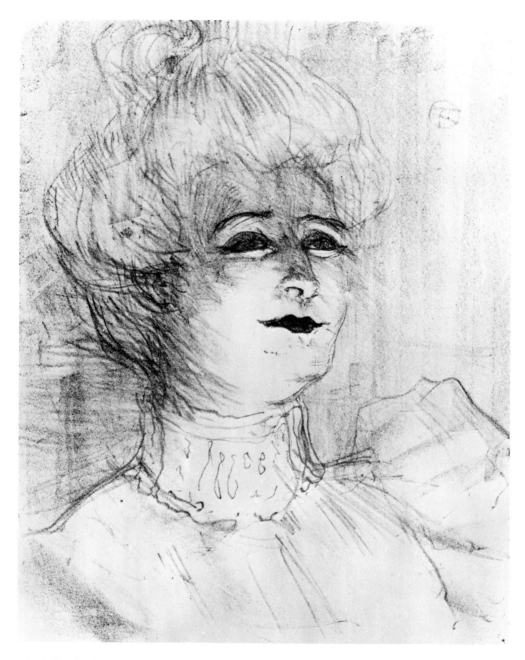

Marie-Louise Marsy. LITHOGRAPH, 1898. DELTEIL 158. This was thought by
Delteil, Adhémar, Adriani-Wittrock and Huisman-Dortu to be possibly
a portrait of Jane Hading.

POLIN

Pierre-Paul Marsalès, known as Polin.

Born in Paris on August 13, 1863. Student at the Gobelin Factory. Debut at the concert at the Pépinière on September 4, 1886; lasted hardly a month there. Then went to the concert at the Point-du-Jour, three months; then to the Eden Concert, 5 years. Next to the Alcazar d'Été, and then entered the Théâtre des Nouveautés where he triumphed in *Champignol malgré lui*. He had a contract for five years which he broke at the end of six months. Mr. Marchand, the manager of the Folies-Bergères, of La Scala, and of the Eldorado offered him a golden opportunity. He pays a penalty of 15,000 francs for breaking his contract and earns four hundred francs per evening to exemplify the French soldier in his ridiculous ways and his naiveté.

Polin. Reproduced from
Le Panorama: Paris s'amuse
No. 1, 1896-1897.

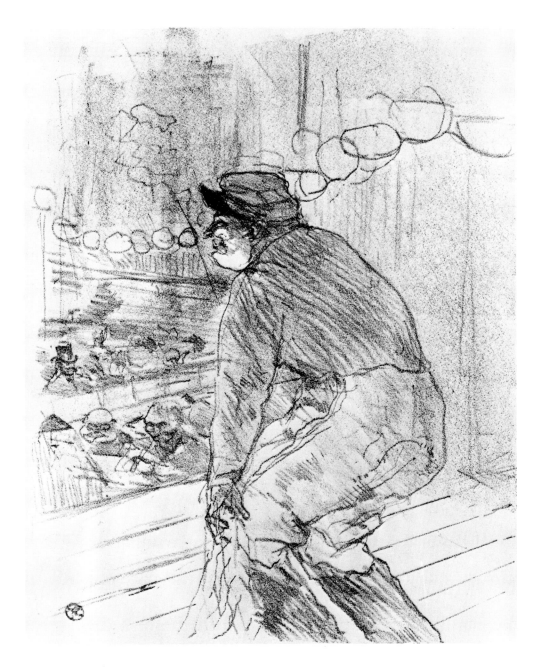

Polin. LITHOGRAPH, 1898. DELTEIL 159.

MAY BELFORT

Born in Ireland, she made her debut in London, then to Paris where she played the Eden Concert, Jardin de Paris, L'Olympia, Décadents, etc. She dressed in flowing robes, a small black cat in her arms, singing in English.

May Belfort. Reproduced from
Le Theatre No. 12, December 1898.
Photographed by Paul Sescau,
a close associate of Toulouse-Lautrec.

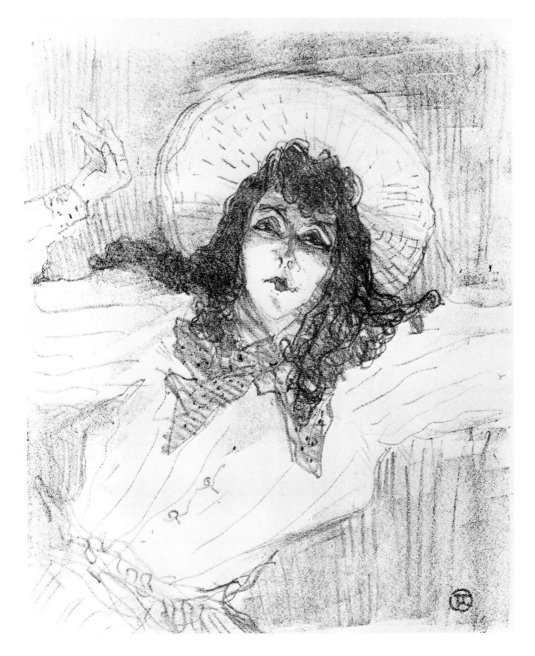

May Belfort. LITHOGRAPH, 1898. DELTEIL 160. Delteil, Huisman-Dortu, and Adriani-Wittrock thought this lithograph was possibly a portrait of Eva Lavallière, while Adhémar thought it was either Lavallière or Polaire.

ÉMILIENNE D'ALENÇON

Born in 1869. Was registered in the files of the registry office under the name of her father, a poor carpentry worker who modestly called himself Legros.

Knew years of wretched miseries while she was an apprentice, and then a laundry worker.

Did theater on the side. It would be too bold to say that she has talent; better than that; she is beautiful; and even when she mumbles on the stage she is applauded violently.

A good girl, somewhat miserly. Some years from now she will retire from public life; will go to live in the country; will devote Sunday to Mass and the Holy Bread.

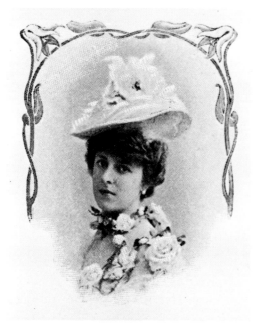

Emilienne d'Alençon.
Reproduced from *Nos Artistes*, 1901
(this issue not a source used by Lautrec).

Emilienne d'Alençon. LITHOGRAPH, 1898. DELTEIL 161. Adhémar thought this might
be either Eva Lavallière or Emilienne d'Alençon.

Jane Hading. LITHOGRAPH, 1898. DELTEIL 162. Thought to be possibly a portrait of Cassive by Delteil, Huisman-Dortu, and Adriani-Wittrock, and of either Cassive or Hading by Adhémar.

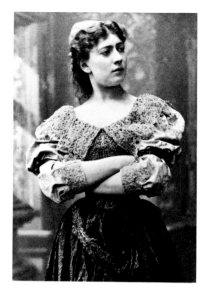

Jane Hading. Reproduced from an undated photograph by Van Bosch.

JANE HADING

Jeannette Hadingue, known as Jane Hading, was born in Marseille on November 25, 1861. Appeared in Marseille at the age of 3 in the role of the Doll of *Bossu*. Did all of her musical and dramatic studies at the conservatory in her native village where she obtained a solfeggio music prize. Went to Algiers where she played in the *Passant, Les Deux Orphelins* and *Ruy Blas*. After a short stay at the Palais-Royal in Paris, she went to the Gymnase Dramatique where she created the *Petite Mariée*. Subsequently played in pieces by Daudet, Ohnet, and Claretie. Married her director Koning, got divorced two years later; entered the Comédie Française. Left the house of Molière in 1895 following a violent altercation with Miss Marsy.

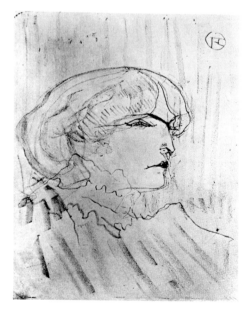

Jane Hading. LITHOGRAPH, 1898.
DELTEIL 262.

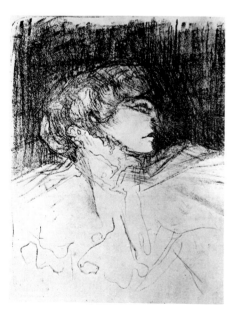

Jane Hading. LITHOGRAPH, 1898. DELTEIL 263, varying from Delteil 162; numbers 262 and 263 must also have been drawn in connection with the Sands project.

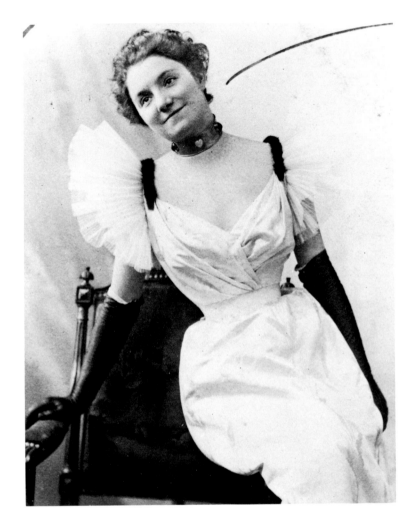

YVETTE GUILBERT
From an undated photograph by G. Camus

Couverture. LITHOGRAPH, 1898. DELTEIL 250.

YVETTE GUILBERT

Frontispiece. LITHOGRAPH, 1898. DELTEIL 251.

Yvette Guilbert

DRAWN BY

H. DE TOULOUSE LAUTREC

DESCRIBED BY

ARTHUR BYL

TRANSLATED BY A. TEXEIRA DE MATTOS

LONDON

BLISS, SANDS & CO.

MDCCCXCVIII

ILLUSTRATIONS

YVETTE GUILBERT

VETTE GUILBERT was born at Paris, on January 20, 1868. This requires investigation. It cannot give Yvette's age! Yvette is of no age: she is youth eternal.

Her mother was an embroiderer of great talent. In 1878 she executed an imperial commission for the Paris International Exhibition.

Upon leaving the elementary school at Saint-Mandé, Yvette was apprenticed to a working dressmaker. But a lack of orders set in and resulted in a terrible period of privation in the modest home of Mlle. Guilbert and her mother, at this time a widow. The young girl had an instinctive love, approaching to adoration, for the stage. She resolved to make it her career, and took lessons from Landrol, an excellent comic actor.

The young *comedienne* made her first appearance on the boards of the Théâtre des Bouffes du Nord, in a gloomy tragedy. She met with no success. She next went to the Eldorado, where she sang a few songs. These also failed to please a public destined not until later to understand the immensity of talent and resource concealed within this tall young girl's attenuated frame. Nevertheless, in spite of her persistent failures, the new actress obtained an engagement at the Éden-Concert. Her luck seemed suddenly to change, and Yvette made a striking success.

Xanrof, the *chansonnier* and poet, compiled a volume of songs, which, interpreted by Yvette, became the rage at the Éden-Concert and in Montmartre. He saw how much there was to be done with the intelligent young artist. He created a new style for her, which is still known in the music-hall world of Paris as the Yvette style. This consisted in singing coldly, and without gestures, songs of a concentrated spiciness

calculated to bring the blush to a monkey's cheek. Not a muscle was brought into play: with her arms hanging loose by her side, her body motionless, her features purposely tense, Yvette sang the most extraordinary things in a very beautiful and silver-toned voice; and this without laughing, without smiling, without underlining even the raciest witticisms with a wink of the eye or a compression of the lips. She simply sang; and the result was a veritable triumph. The music-halls were entirely revolutionized by the new method, and have still reason to be infinitely grateful to the astonishing artist who has rid them, to so great an extent, of the dull, unliterary, nonsensical coarseness of an earlier period. Quite a cluster of talented young poets have devoted themselves to song-writing since the day when they secured Yvette Guilbert as their interpreter.

From the Divan Japonais, the music-hall at Montmartre to which Xanrof had secured her admission, she passed to the Concert Parisien in the Rue du Faubourg Saint-Denis, where she sang at a salary of three hundred francs a night. It was here that her extraordinary fortune commenced. She remained four years at this establishment, where all that was elegant in Paris came to hear her. At the end of her engagement she moved to the Scala, at a monthly salary of 21,000 francs.

From this moment each new creation of the charming *divette* became a popular success. To quote from memory: *Le Fiacre, L'Hôtel du numéro 3, L'Encombrement, Le Serpent de Sarah, Ballade du vitriol, Sur la scène, La Tour Eyffel*—these and a hundred other songs have been sung by a million throats.

These enormous successes, obtained with songs of a purely comic or suggestive character, did not satisfy the young and conscientious artist. She longed to make her audiences weep and tremble. Haunted by the memory of Thérésa, she attempted sentimental and tragic songs. She does not make us forget her illustrious predecessor, nor, for that matter, does she imitate her: she simply obtains the same effects by other methods.

From the commencement of her fortune, Yvette went to live in the country, in the neighbourhood of Paris. She hired, and then bought, a tiny and very modest little house. This rudimentary residence has since, by means of successive additions, developed into a magnificent villa, almost a country-house. She lives in it during the greater part of the year. Nevertheless, she has a *pied-à-terre* in Paris, a very luxurious flat at 79, Avenue de Villiers, for which she pays 10,000 francs a year. But she vastly prefers her rustic property at Vaux, in the Department of Seine-et-Oise.

Leaving her art on one side, she is very religious. She regularly fulfils the duties prescribed by her Church. She has had the steeple of Mureaux-près-Vaux rebuilt at

her expense. The *cure* talks with admiration in his sermons of his generous parishioner.

In London, Yvette Guilbert took us by storm at the first hearing. She sang two songs in English—extremely bad English—*Linger longer, Loo*, and *I love you, my Honey*, throwing into the latter an astounding amount of passion, which showed that, if she could not pronounce, she could at least understand the words of the song better than any of our native exponents.

After a triumphal tour in Germany, she has returned to the Scala in Paris. There she has created a number of new songs, which we shall doubtless soon hear in London. These include, in the first place, *La Glu*, by Jean Richepin ; then, *Le Moulin Rouge*, by Boukay, *alias* Couyba, the song-writing Deputy ; *Trou lo lo itou*, by Briollet ; *L'Ancienne maîtresse*, by Doucet—oh no, not the Academician—and *Les Michettes* and *L'Ingénue de Grenelles*, by Gil. There are both laughter and tears in Yvette's *répertoire*.

She is really a very great artist, this thin, undulating, almost ugly woman. Life is kind to her to-day, and she deserves to be congratulated. She has known days of misery : it is but just that she should now enjoy long years of happiness and success.

Sur la Scène. LITHOGRAPH, 1898. DELTEIL 252.

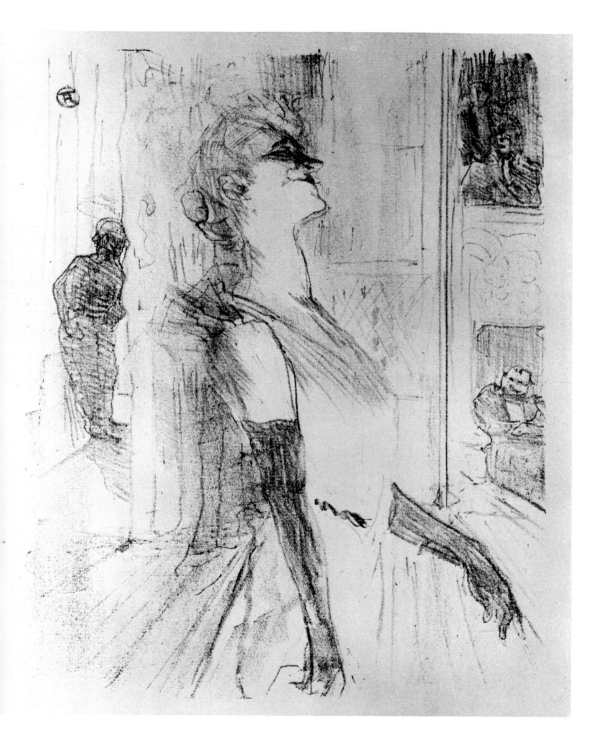

Dans la Glu. LITHOGRAPH, 1898. DELTEIL 253.

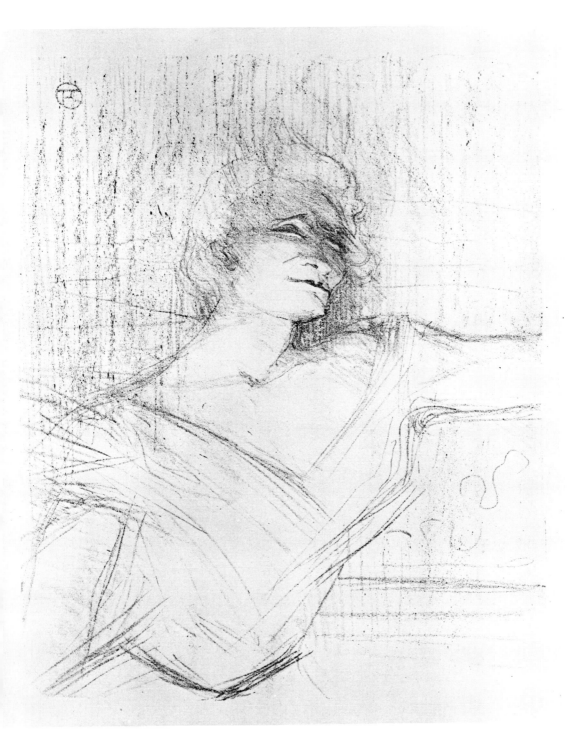

Pessima. LITHOGRAPH, 1898. DELTEIL 254.

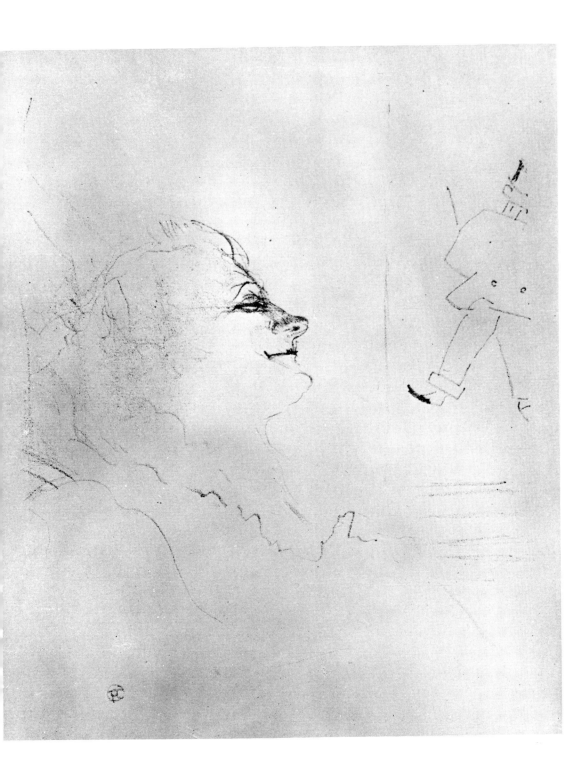

A Menilmontant, de Bruant. LITHOGRAPH, 1898. DELTEIL 255.

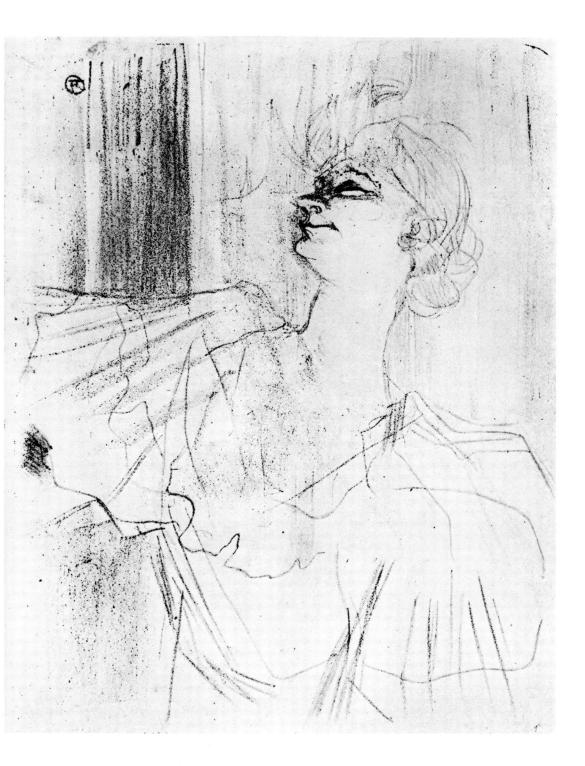

Chanson Ancienne. LITHOGRAPH, 1898. DELTEIL 257.

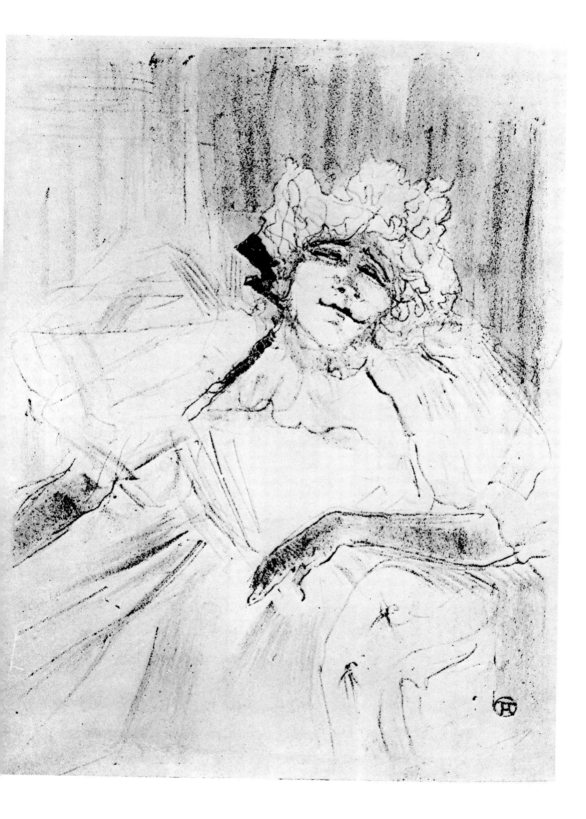

Soularde. LITHOGRAPH, 1898. DELTEIL 258.

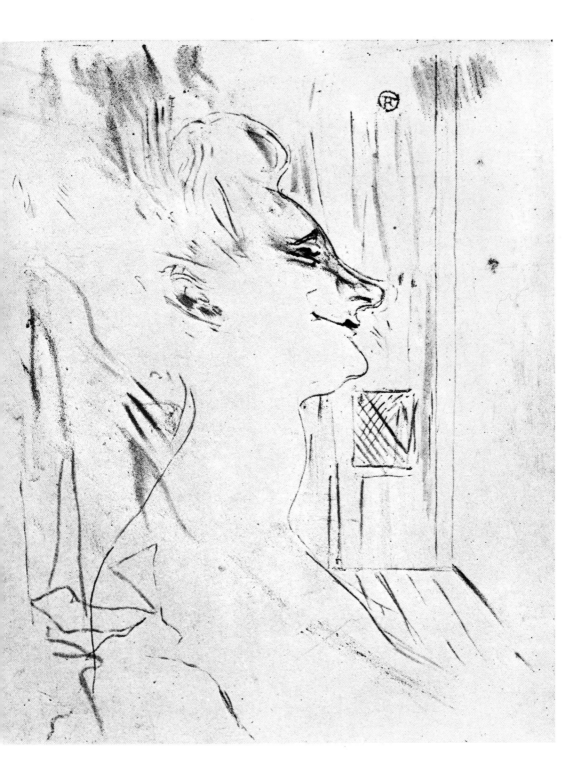

Linger, Longer, Loo. LITHOGRAPH, 1898. DELTEIL 259.

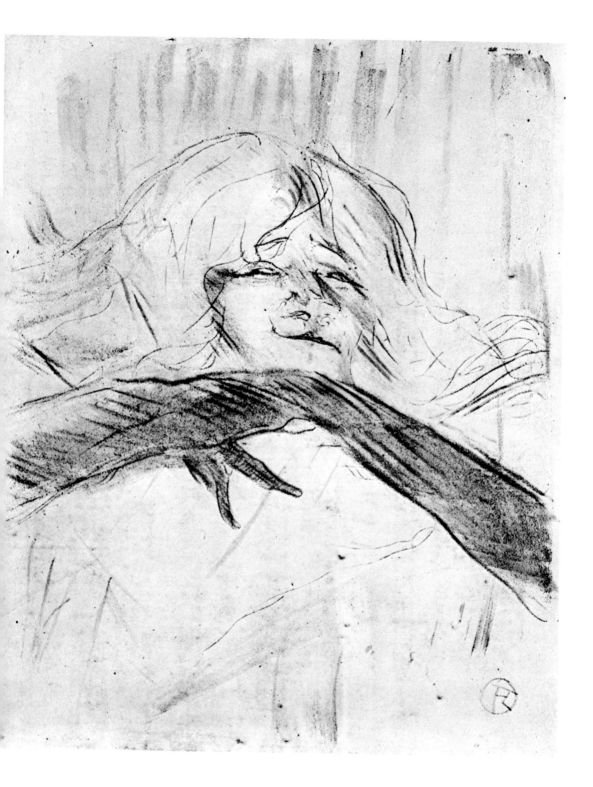

Saluant le Public. LITHOGRAPH, 1898. DELTEIL 260.

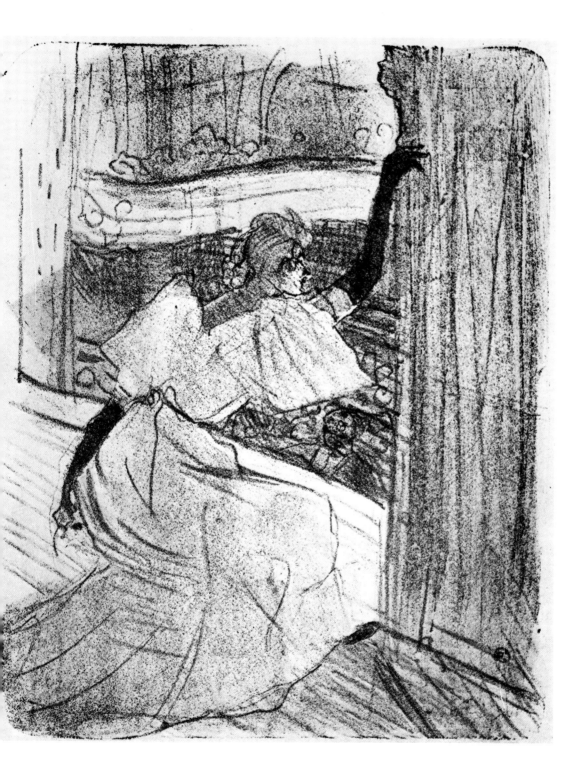

Actors and Actresses Not Included in

TREIZE LITHOGRAPHIES

The fourteen persons in the following pages were not included in the published version of the book but were mentioned in the letters as possibilities. They include four, Polaire, Réjane, Eugene-Alexis Edmond Rostand, and Emma Calvé, whose portraits were drawn by Toulouse-Lautrec; one, Mounet-Sully, whose biography was written by Arthur Byl and was included in the Sands papers; and nine with neither portraits drawn by Toulouse-Lautrec nor available biographies by Arthur Byl.

POLAIRE

Born Émilie-Marie Bouchaud in Algeria. Worked in Paris in the 1890s at Ambassadeurs, Folies-Bergères, Eldorado, La Scala.[1]

1. This brief statement was prepared by the editors using information in her autobiography, *Polaire par Elle Méme,* Editions Eugène Figuière, Paris, 1933. Using various sources, one could not even be certain of her name or age. "Émilie Zouzée dite Polaire," said Delteil. "Known as Eve Lavallière," said Adhémar. "Louise Balthy was known as Polaire," said Liane de Pougy in *Mes Cahiers Bleus* (Plon, Paris, 1977). And "Née Le 13 Mai 1879" said Delteil. But "J'ai vue le jour le 13 Mai 188–" said Polaire.

Polaire. Unknown source, c. 1898.

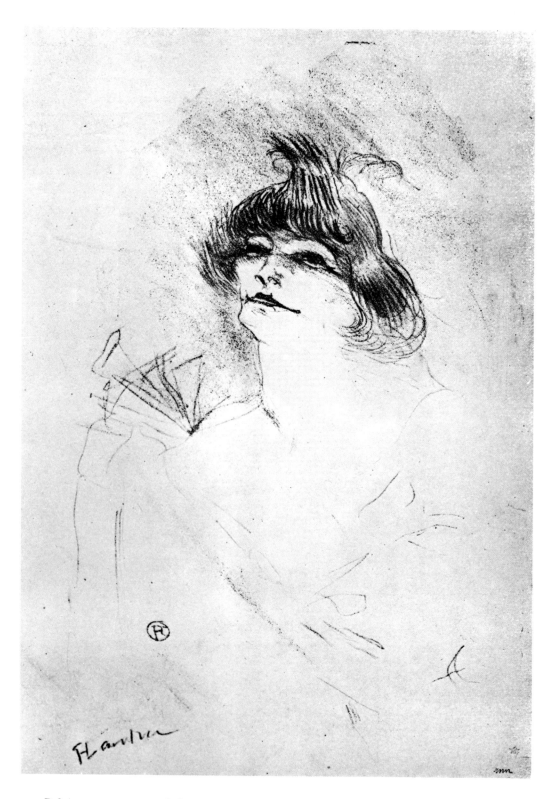

Polaire. LITHOGRAPH, 1898. DELTEIL 227. This lithograph is first mentioned in mid-January 1898 (letter no. 4) and was completed and sent to Sands together with the Byl text by February 25, 1898 (letter no. 6). It was not included in the series as published, but was reproduced in *The Paris Magazine* Vol. I, No. 1 (Sands & Co., London; Clarke & Co., Paris, December 1898).

RÉJANE

Born in Paris 1857. Debut at Vaudeville in Revue Des Deux Mondes *('75).*
Appeared in Mlle. Lili, Le Premier Tapis, Le Club, *etc. Quit Vaudeville in '82*
and appeared in various places, in La Glu *('82)*, Clara Soleil *('83)*, Décoré
('88), Germinie Lacerteux *('88)*, Shylock *(89)*, Ma Cousine *('90)*, Lysistrata
('92), Mme. Sans-Gêne *('93)*, Maison de Poupée *('94)*, Partage *('96)*, Zaza
('98), *and* Paméla, *which opened February 11, 1898.*

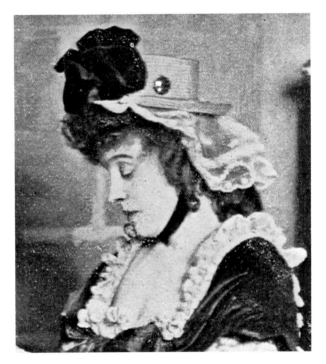

Réjane (detail) as Paméla.
Reproduced from *Le Théâtre*
No. 3, March 1898.

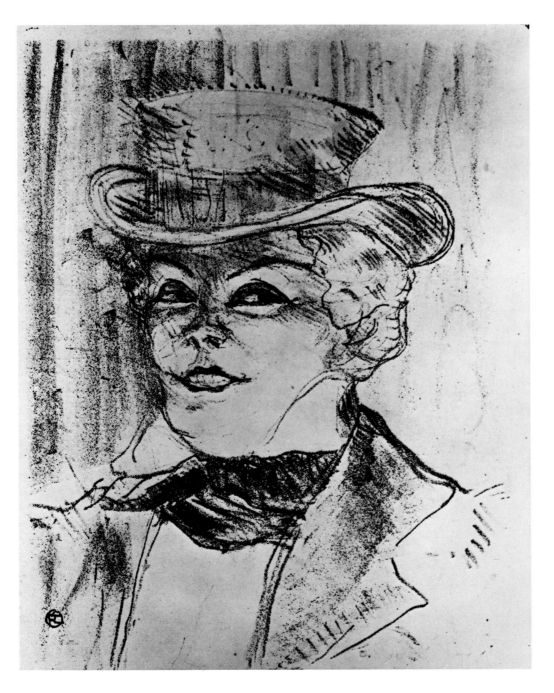

Réjane. LITHOGRAPH, 1898. DELTEIL 266. Drawn in 1898, this lithograph did not appear in the series as finally issued. It seems closely related to the 1894 lithograph *Réjane et Galipaux, dans Madame Sans-Géne* (Delteil 52).

EDMOND ROSTAND

*Born in Marseille 1868 where he studied, then went to Paris to Collège Stan-
islas. Debut in theatre with* Le Gant Rouge *('88), then* Les Romanesques
('91), La Princesse Lointaine *('95),* La Samaritaine *('97),* Cyrano de Ber-
gerac *('97).*

Edmond Rostand (photo reversed.)
Reproduced from *Nos Auteurs et
Compositeurs Dramatiques,* 1897.

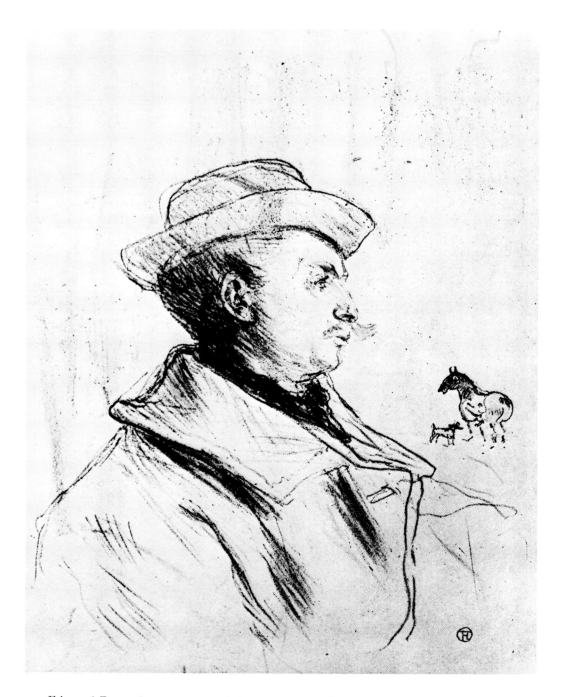

Edmond Rostand. LITHOGRAPH, 1898. DELTEIL 291. The editors believe that this represents Edmond Rostand and not Edmond Calmèse as identified thus by Delteil and all others. There seems little doubt that Toulouse-Lautrec prepared a lithographic portrait of Rostand as detailed in the letters. This lithograph was drawn in 1898 and its size is similar to others in the series. According to Dortu, there is only one known drawing of Calmèse (Dortu 4.567) and she did not reproduce it. The editors have not been able to locate any likeness of him. The reasonably well-dressed sporstman pictured in the lithograph is unlike the person described in the letters of Berthe Sarrazin in Goldschmidt and Schimmel (London) 245, 246, 251, 252, 259, 267, where he is variously described as a drunk, a pig, a demon, terrible, and sloppy.

EMMA CALVÉ

Born in Madrid 1864, student of Marchesi and Puget, made her debut in Nice and then Bruxelles as Marguerite in Faust *('82). To Paris,* Aben Hamet *('84),* Les Pêcheurs de Perles *('89). Travels to Italy, America, and England. Back in Paris* Cavalleria Rusticana *('92),* La Navarraise *('95), and* Sapho *('97).*

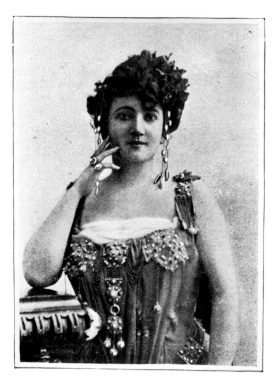

Emma Calvé in *Sapho*.
Reproduced from *Le Théâtre*
No. 1, January 1898.

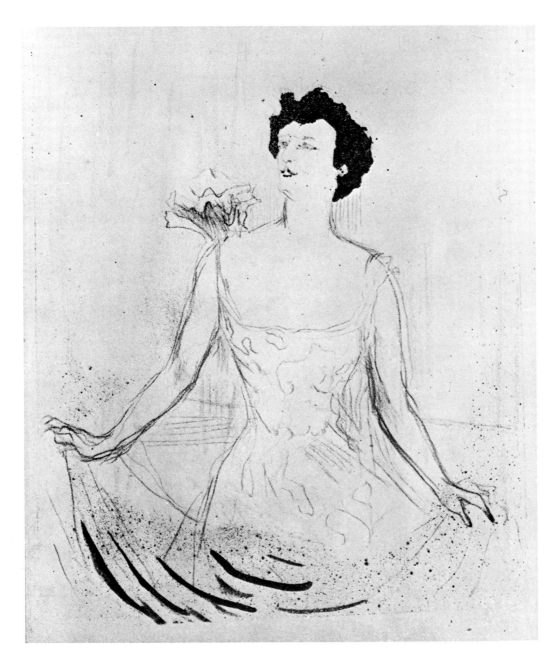

Emma Calvé. LITHOGRAPH, 1898. DELTEIL 213. The editors believe that this is Emma Calvé and not an unidentified actress on stage, as believed by Delteil and all others. It is dated 1897 by Delteil, 1898 by Adhémar, and 1899 by Adriani-Wittrock. Toulouse-Lautrec prepared a lithograph of Calvé as detailed in the letters. This one is similar in size to the others in the series and similar in appearance to the singer.

MOUNET-SULLY

Born in Bergerac on February 27, 1841. Did serious studies at Toulouse and went to Paris to compete for the Conservatory in spite of his parents' wishes. After two years of studies, he received a prize for tragedy and was engaged by the Odéon in 1868, where he played *King Lear, Le Bâtard,* and *Lucrèce* without particularly attracting attention. Received prominence due to some happy creations at the Ballande matinees. Debut at Comédie Française in 1872 in the role of Orestes. Prodigious success.

He spoils his very real gifts by excessive vanity. The following sharp observation is attributed to Emile Augier during a rehearsal of *Jean de Thomeray:*

"For heaven sakes, my dear sir, try to have a little less genius and a little more talent!"

This paints the picture of the man.

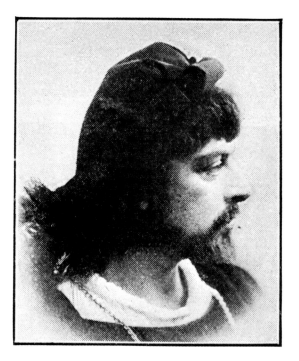

Jean Mounet-Sully. Reproduced from *Nos Artistes,* 1895. No portrait of Mounet-Sully was prepared by Toulouse-Lautrec for this series. He drew *Bartet et Mounet-Sully dans Antigone,* 1894. (Delteil 53).

ANDRÉ ANTOINE[1]

Born at Limoges in 1858, worked for the gas company and as an amateur actor until founding of the Théâtre-Libre in '87. He also worked at Gymnase, Renaissance Odéon, Menus-Plaisirs, and Théâtre Antoine. Produced over 100 plays at Théâtre Libre and appeared in L'Age Difficile *('95),* La Figurante *('96).*

1. A biography was written for Antoine by Arthur Byl but was not among the Sands papers.

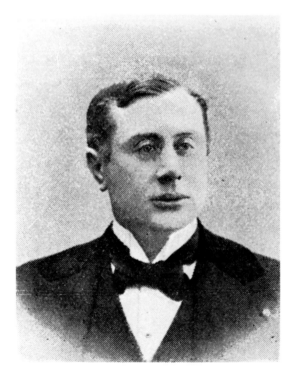

André Antoine. Reproduced from *Nos Artistes*, 1901 (also pictured in 1895 edition). No portrait of Antoine was prepared by Toulouse-Lautrec for this series. He drew *Au Théâtre Libre: Antoine dans L'Inquiétude*, 1894 (Delteil 51), *Antoine et Gemier dans Une Faillite*, 1894 (Delteil 63), and *Yahne et Antoine dans L'Age Difficile*, 1895. (Delteil 112).

FRÉDÉRIC FEBVRE

Born in Paris 1833. Played at La Porte-St.-Martin, Gaité, Odéon, Vaudeville and Comédie-Française from 1866 to 1893, creating and performing hundreds of roles.

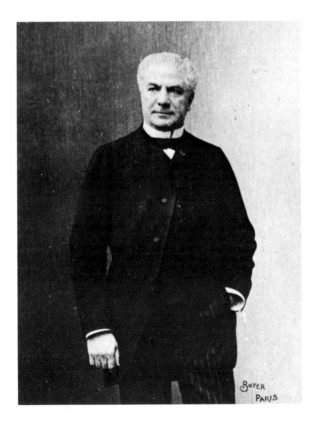

Frédéric Febvre. Reproduced from a photograph by Boyer, c. 1890s. No portrait of Febvre was prepared by Toulouse-Lautrec for this series.

LITTLE TICH (HARRY RELPH)

Born in a village in Kent, England, in 1868. Took his name because of his small stature and as an allusion to the Tichborne Claimant, a prominent trial of the time. A pantomimist with an extraordinary group of characters in his repertoire. Played Tivoli, Pavillion in London, and Folies Bergère in Paris, early 1898.[1]

1. This biography was prepared by the editors from modern sources. No biography of Little Tich was prepared by Arthur Byl for this series.

Little Tich. Reproduced from unknown source, c. 1890s. No portrait of Little Tich was prepared by Toulouse-Lautrec for this series.

MARGUERITE UGALDE

Born in Paris 1862. Debut at Opera-Comique in Fille du Régiment, *('80),* **then** *in* Contes d'Hoffmann. *Joined Nouveautés, played in* L'Oiseau Bleu *('84). Joined Bouffes ('87), Gymnase ('90), Variétés playing in* Chilpéric *('95),* **then** *to Eldorado ('96).*[1]

1. No biography of Ugalde was prepared by Arthur Byl for this series.

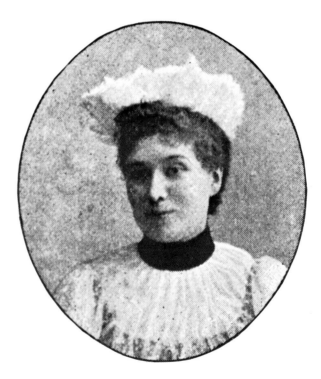

Marguerite Ugalde. Reproduced from *Nos Artistes*, 1895. No portrait of Ugalde was prepared by Toulouse-Lautrec for this series.

ALBERT-JULES BRASSEUR

Born Paris 1862, debut at Nouveautés in Fleur D'Oranger *('79), and appeared in a great many plays at that theater until entering Variétés ('90). He appeared in* Paris Port De Mer *('91),* La Bonne à Tout Faire *('92),* Mme. Satan *('93),* Paris Qui Marche *('97),* Le Nouveau Jeu *('98).*[1]

1. No biography of Brasseur was prepared by Arthur Byl for this series.

Albert-Jules Brasseur. Reproduced from *Le Théâtre* No. 3, March 1898. No portrait of Brasseur was prepared by Toulouse-Lautrec for this series. He drew *Aux Variétés: Mlle. Lender et Brasseur,* 1893 (Delteil 41), *Entrée du Brasseur dans Chilpéric,* 1895 (Delteil 110), *Mme. Simon-Girard, Brasseur et Guy dans La Belle Hélène,* 1895 (Delteil 114).

AINO ACKTÉ

*Born in Finland 1876, entered the Paris Conservatory ('94) and made her debut
at the Opéra in October '97 as Juliette in* Romeo.[1]

1. No biography of Ackté was prepared by Arthur Byl for this series.

Aino Ackté. Reproduced from *Nos Artistes*, 1901. No portrait of Ackté was prepared by
Toulouse-Lautrec for this series.

MARIE DELNA

Born in Paris, debut at Opéra-Comique in Troyens *('92). Sang in* Werther *('93),* Falstaff *('94),* Don Juan *('96). Debut at Opéra in* Prophète *('98).*[1]

1. No biography of Delna was prepared by Arthur Byl for this series.

Marie Delna. Reproduced from *Nos Artistes*, 1901 (also pictured in 1895 edition). No portrait of Delna was prepared by Toulouse-Lautrec for this series.

CATULLE MENDÈS

Born in Bordeaux 1841. Went to Paris to follow literary career. Founded Revue Fantaisiste *('61), an organ of the Parnassiens. Wrote poetry, novels, and plays. His best known works are* Les Folies Amoureuses *('77),* Legende du Parnasse Contemporain *('84),* La Reine Fiamette *('89),* Le Docteur Blanc *('93),* Chant d'Habits *('96).*[1]

1. No biography of Catulle Mendès was prepared by Arthur Byl for this series.

Catulle Mendès. Reproduced from *Nos Auteurs et Compositeurs Dramatiques*, 1897. No portrait of Catulle Mendès was prepared by Toulouse-Lautrec for this series.

JOSEPHINE INVERNIZZI

Born in Milan, studied at La Scala, then Paris Opéra. Played in Farandole,
Coppélia, Sylvia, Colombine, Pardonnée, Le Docteur Blanc *and so on.*[1]

1. No biography of Invernizzi was prepared by Arthur Byl for this series.

Josephine Invernizzi. Reproduced from *Nos Artistes*, 1901 (also pictured in 1895 edition).
No portrait of Invernizzi was prepared by Toulouse-Lautrec for this series.

Transcriptions of the Original Letters

The original letters contain inconsistencies and numerous
small errors, accents and hyphens omitted, for example.
All of these are carried over in the transcriptions.

TRANSCRIPTIONS OF THE
ORIGINAL LETTERS

1. TO W.H.B. SANDS, LONDON

[Paris, July 6, 1896]

Cher Monsieur

J'apprends par Spoke que vous avez à m'écrire quelque chose au sujet d'un livre. Je suis à Paris encore pour 4 jours 30 rue Fontaine. Merci de votre aimable lettre et dans l'espoir de vous lire

Cordialement à vous

H. de T. Lautrec

P.S. Je vous prie de présenter mes hommages respectueux à Mme Sands.

2. TO W.H.B. SANDS, LONDON

[Paris, June 2, 1897]

Cher Monsieur—

Merci pour vénus et apollon j'ai indiqué votre livre à plusieurs personnes qui vous écriront.

Je pense beaucoup à notre livre à faire. Mais je ne crois pas être prêt avant Noël. Ce sera déja bien si nous avons fini à ce moment là.—

J'aurai les meilleurs écrivains pour cela: Geffroy, Descaves, Tristan Bernard, etc. Nous pourrons faire une édition anglaise et une édition Française.

Mes hommages à Mrs. Sands et

Yours truly

H. T. Lautrec

I shall perhaps be over soon.

Your HTL

3. TO W.H.B. SANDS, LONDON

[Paris] 25 Decembre 1897
Saturday

Cher Monsieur,

J'ai recu par M. Joyant le chèque de 12 livres et vous en remercie. Je pense au livre futur et vous en écrirai.

Yours truly

H de Toulouse Lautrec

4. TO W.H.B. SANDS, LONDON

[Paris] 15 avenue Frochot

[mid-January, 1898]

Cher Monsieur

Je vous demande pardon d'écrire si tard, mais j'ai été occupé à installer ma famille à Paris et je n'ai pas eu de temps. Pour votre livre je crois que 30 personnalités c'est trop, il vaut mieux 20, et on est plus sûr de réussir. Ça coutera pour 300 exemplaires comme Polaire 33 f. pour imprimer sans compter le papier.

Je vous prendrai *100 f par dessin* pour moi. Voyez ce que vous pourrez donner pour payer les littérateurs. Envoyez moi des chiffres et croyez que ça sera pour le mieux. Je compte aller à Londres au printemps mais mon ami Joyant ira dans quelques jours.—

Si vous pouviez en m'écrivant me fixer le prix d'une petite salle d'exposition très select pour 15 jours au mois de Mars ou Avril vous *me rendriez service*. Je vous prie de présenter

mes hommages à Madame Sands et de me croire

Yours truly
H. de T. Lautrec

[Note at top of letter by a person in Sands's office:]

Feb. 15/98
Better no text. Cannot use Yvette G. Say 200 or 250 at 1 or 2 Gs. per copy. ? French ed^{on} suggest paying L— a royalty per copy of Fr Edn sold.

5. TO W.H.B. SANDS, LONDON

[Paris] 14 Janvier 1898

Cher Monsieur

J'ai reçu votre epreuve qui est très bien. Si vous pouvez garder le fond back ground *plus blanc* (*white*) et les cheveux de la dame assise un peu moins lourds ce sera mieux. Je vous envoie une Sarah Bernhardt avec le texte.*
Je crois que le texte vaut 100 frs. par article.

Repondez moi votre avis

Yours truly
H T Lautrec

15 av. Frochot

* par A. Byl

6. TO W.H.B. SANDS, LONDON

Envoyez mois les échantillons de papier s.v.p.	25 Fevrier 1898 15 avenue Frochot Paris

Cher Monsieur

Votre lettre est très sensée et je vous communique la liste déjà écrite de mon collaborateur Byl auquel vous devez les articles suivants au prix convenu de 100 f. (cent francs chacun)

Sarah
Coquelin
Calvé
Polaire
Yvette Guilbert
Rostand

C'est à dire 600 f. Il fera les 19 autres en forme de médaillons (short style) dans les dimensions que vous lui indiquerez, et naturellement à un prix proportionnellement moindre.—Ecrivez mois a ce sujet, le plus tôt possible. Maintenant il est prêt à enlever d'Yvette Guilbert et des autres que vous nous indiquerez tout ce qui pourrait nuire à la vente du livre.

Je vous envoie Polaire (texte) et vous aurez les sus-indiqués au plus tôt des qu'ils seront au net.

Je vous envoie aussi les dessins de

Sarah
Yvette
Polaire
Anna Held
Polin
May Belfort
Émilienne d'Alençon
Granier

Quant aux originaux ils sont directement sur pierre. Chaque pierre coute 3 francs.—
Ecrivez mois au plus tôt et croyez moi cordialement à vous

H de Toulouse Lautrec

7. TO H. DE TOULOUSE-LAUTREC, PARIS

12, Burleigh Street, Strand
London, Feb. 28, 1898

Mon cher M.

Merci de votre lettre.

Je crois qu'il sera mieux que M. Byl ecrive les autres à peu près comme ci-dessous

 Quelque chose comme cela—quatre lignes.

Si M. Byl voudrait écrire les médaillons nous pourrions toujours les amplifier plus tard comme les autres.

Voulez vous me dire s'il veut que je lui paie toute suite, ou à la fin. Maintenant j'ai Sarah B. et Y.G.—J'attends de vous renvoyer Y. pour indiquer les choses qui doit être enlevée.

Vous dites—Envoyez moi les échantillons de papier—J'ai mal compris ce que vous désirez—est ce le papier sur lequel il faut tirer, ou les dessins que vous m'avez déjà envoyés viz. Sarah B. & Polaire? Expliquez, cher Monsieur, dans votre prochaine lettre.

Maintenant je crois que vous aurez les 25 dessins prêts pour tirer, vers la fin de Mars—mais sûrtout pouvez vous me donner 6 dessins d'Yvette G. toute suite, c'est à dire dans 2 ou 3 semaines.

Je crois que ces dessins se voudraient en grande quantité au commencement de Mai, quand elle sera t'ici [sic]. Ce serait quelque chose pour nous deux, et aussi un peu de réclame—la meilleur—pour vous, parce que ce sera le beau monde qui les verra. Excusez mois, je vous prie, mon écriture, et mon Français

Cordialement à vous
W H B S

8. TO W.H.B. SANDS, LONDON

Paris le 28 fevrier 1898

[Letterhead] Henry's Hotel
11, rue Volney
Cable Address
"Henrysotel"

Cher Monsieur

Je vous ai envoyé une epreuve d'Yvette Guilbert sur du papier qui n'est pas mal. Si vous en avez du meilleur envoyez moi des échantillons.

Pour le paiement de Byl vous m'enverrez le chèque quand les six articles commencés seront livrés. Pour les médaillons il les fera au prix de 50f. (deux livres.)

Pour Yvette Guilbert voulez vous des dessins différents, ou des épreuves du même. Sur quel Papier? R.s.v.p. au plus tôt

Yours truly
HTLautrec

9. TO H. DE TOULOUSE-LAUTREC, PARIS

[London] Mars 1/98

Cher Monsieur
Merci de votre lettre.

Les 6 dessins d'Yvette Guilbert je les voudrais s'il est possible, de vous sur papier parce qu'il est presque absolument nécessaire de les faire imprimer ici à Londres—la vente sera pendant deux ou trois semaines, et il nous faut être prêts pour imprimer toute suite une grande quantité, et de les avoir prêts à la main. Pouvez vous me donner 6 dessins comme celui que vous m'avez déja envoyé—n'importe quels—sur papier. Je suis sûr qu'ils auront beaucoup de succès.

M. "Byl"—pour les médaillons je ne voudrais que 4 lignes au plus, ou peutêtre 6—Je trouve que pour si peu son prix—50fr. est un peu elevé. Je voudrais économiser sur le texte ainsi que je puisse depenser plus sur le papier la réliure et les annonces, dans les journaux, les affiches etc. Vous voyez que pour une edition de 250 exemplaires—at 30 shillings—nous toucherons par exemplaire 13/12, à peu près 20 shill.—c'est à dire 25 fr. Ca apporte 250 livres pour tout. Croyez vous qu'il les ferait, ces medaillons pour 25 fr. chacun? Si non je crois qu'il nous faudra faire écrire quelques lignes ici en Anglais, cueillies des journaux, & C. Quant à l'édition Française, je voudrais faire tirer 100 exemplaires a 50 fr. et vous payer 15% comme royauté.

Vous comprenez que c'est vous et vos dessins dont il s'agit—le texte n'est pas très nécessaire—et moins que nous dépensons sur le texte, plus nous pouvons mettre dans les dessins. Quand est ce que vous viendrez à Londres il fait beau à ce moment!

Il vous faut venir.

Bien cordialement à vous.
WHBS

Transcriptions of the Original Letters

10. TO W.H.B. SANDS, LONDON

[Paris] March 1, [1898]

Cher Monsieur,

Je vous envoie Calvé, Coquelin et Rostand. Vous m'envoyez le chèque de 600 fr. pour Byl dès que vous pouvez. Il est un type très gentleman et qui n'exige pas d'argent mais je crois qu'il sera très content de toucher. Je vous enverrai les épreuves de mes dessins demain ou après demain.

Yours truly,
H. de Toulouse-Lautrec

11. TO W.H.B. SANDS, LONDON

[Paris] Samedi [probably March 5, 1898]

Cher Monsieur

Je vous remercie de la part de "Byl" du chèque de 600 f

Nous aurons les 25 prêts pour la fin de mois si rien d'accidentel n'arrive. Je vous envoie les dessins déja faits des artistes suivants

Polaire (vous l'avez)	1
May Belfort	2
Anna Held	3
Polin	4
Sarah Bernhardt	5
Emilienne d'Alençon	6
Granier ?	
I shall do a better one	7

J'ai encore à faire d'une façon certaine

Calvé
Rostand } dont Byl a fait le texte.
Coquelin

Byl fera les médaillons au prix de 25 francs.

Je vous enverrai demain deux nouveaux dessins d'Yvette. Si vous voulez on les imprimera ici sur le papier du premier que je vous ai envoyé qui n'est pas mal. Si vous avez mieux envoyez nous le papier ou dites

qu'on vous envoie les pierres (ad libitum)—

Pour l'Édition française je n'ai pas encore d'idée mais il vaudra mieux tout imprimer à la fois.—Donnez la taille exacte de la marge que vous désirez pour le livre et pour Yvette.

Yours truly
H de Toulouse Lautrec

Byl propose les noms suivants pour continuer à votre choix Ecrivez moi à ce sujet

1	Réjane	10	Sybil Sanderson
2	Febvre	11	Ackté——
3	Louise Marsy	12	Marguerite Ugalde
4	Balthy——	13	Brasseur fils
5	Hading	14	Antoine
6	Guitry	15	Mounet-Sully
7	Cléo de Mérode——	16	Catulle Mendès
8	Invernizzi——	17	Little Tich ?
9	Delna		

Si vous voyez mieux dites le nous
Yours truly HTL

Envoyez s.v.p. le texte d'Yvette pour le corriger.

12. TO W.H.B. SANDS, LONDON

[Paris] 8 Mars [1898]

Cher Monsieur

Je vous envoie deux dessins d'Yvette Guilbert dans Pessima—et dans le role de la *vieille grand mère*.

Yours truly
HTLautrec

13. TO H. DE TOULOUSE-LAUTREC, PARIS

London

Mars 13 [18]98
Cher Monsieur

J'ai maintenant 4 'Yvette'—mon idée est de faire une album—combien de dessins croyez vous seront nécessaires? Comme j'ai vous dit à mon avis 6—et je vous renverrai l'article sur

[170]

elle pour que Byl peuve enlever quelque chose. Cette article doit être plus au sujet de ses succès—par example, qu'elle a chanté depuis ? ans—qu'elle habite un appartement dans la rue ? Qu'elle s'est mariée avec ? Qu'elle aime bien les oiseaux, les chats, les choses comme cela—que son métier est ? Quel genre de chanson elle aime le mieux— qu'elle a chanté sûrtout à La Scala—des petites choses comme cela.

Aussi je voudrais que vous me donniez un 'estimate'

A. combien couterait il, papier, tirage etc., pour tirer 200–250–300–350 au même grandeur que les dessins que vous m'avez envoyés ? *pas de reliure* qu'on peut faire ici.

B. combien les pierres? ceci parceque j'ai aussi une idée que tirer une grande quantité plus petite réussirait—qu'en pensez vous?

C. Croyez vous qu'elle voudrait signer? ce serait quelque chose. Elle sera ici, à Londres, au commencement de Mai, alors il nous faut lancer le livre au milieu d'Avril.

S'il est possible qu'on fasse le tirage à Paris, je crois que le nom 'Goupil' sera sur la reliure. La maison ne travaille pas a Londres, n'est ce pas?

Mes compliments devouées

W H B Sands

Ecrivez moi toute de suite s.v.p. s'il vous déplairait si on tire *une grande quantité,* petite coûte, 3 fr. ou 5 fr.?—naturellement vous partageriez dans les bénefices outre le prix pour les pierres et dessins. Je crois que c'est une bonne idée.

14. TO W.H.B. SANDS, LONDON

[Paris, March 14, 1898]
Lundi

Cher Monsieur

Je vous envoie encore une Yvette Guilbert. Je répondrai demain aux autres questions.

Yours truly
H de T. Lautrec

15. TO W.H.B. SANDS, LONDON

[Paris] 16 Mars 1898

Cher Monsieur

L'Yvette Guilbert que vous m'avez indiquée n'est pas encore tout à fait prêt. Envoyez mois le texte pour le faire arranger par Byl tout de suite.

La maison Goupil ne peut pas se charger d'impressions lithographiques. Ils s'occupent seulement d'aquatintes et photogravures. Je vous envoie aussi le prix de mon imprimeur pour l'impression et le papier.—

Mon exposition ouvrira Regent's street chez Boussod et Valadon le 1er Mai. Je serai à Londres vers le 20 avril ou le 23.—

Je vais avoir encore plusieurs dessins à vous envoyer dans 3 ou 4 jours—Calvé, Rostand, etc. L'imprimeur a demandé plus cher pour ce tirage car il faut mouiller le papier davantage.—

Si la maison peut m'envoyer le prix des dessins déja livrés vous me rendrez service car j'ai beaucoup à payer en ce moment. Pardon si c'est indiscret.—Yours truly
HTLautrec
15 av-
Frochot

16. TO H. DE TOULOUSE-LAUTREC, PARIS

LONDON . . . March 18 . . . 1898

Lautrec

Pour l'autre livre—vous avez dejà fait je crois 6—vous êtes en train de faire aussi Calvé, Rostand, Coquelin, Granier, ce fera 10 en tout—les autres seraient je pense Réjane, Marsy, Febvre, Hading, Delna, Sanderson, Mendes, Sully, pour sûr, ce fera 18 en tout et nous pourrions décider pour les autres quand vous serez à Londres.

[No signature W.H.B. Sands]

17. TO W.H.B. SANDS, LONDON

[Paris] Vendredi 18 mars [1898]

Cher Monsieur
Je vous envoie l'Yvette Guilbert demandée
Yours truly
HTLautrec

J'ai plusieurs médaillons de Byl que je vous enverrai au plus tôt.

18. TO W.H.B. SANDS, LONDON

[Paris] 20 Mars [1898]

Cher Monsieur
Je vous remercie du chèque de 500f. Vous avez du recevoir encore une Yvette. Cela fera 6. J'en ferai encore 2 comme vous le demandez. Je vous envoie en meme temps les médaillons de
Balthy
Mounet-Sully
M. L. Marsy
Émilienne d'Alençon*
Jane Hading*
Polin*
par Byl.
J'ai mis une croix à ceux qui sont déja dessinés.
J'ai également exécuté Constant Coquelin dont vous avez le texte. Je vous ferai envoyer les pierres d'Yvette demain matin Lundi. Le prix de chaque pierre est de 2 f.50 ou 3 francs selon l'épreuve. Le compte de cela sera payable à la fin en bloc.—
Pour l'édition française ecrivez donc à Floury pour lui poser des conditions. Je crois qu'il marchera. Si non je trouverai autre chose.
Yours truly
H de Toulouse Lautrec

Byl est après Yvette Guilbert. Il vous enverra deux articles dissemblables un critique et l'autre flatteur vous choisirez.
HTL
20 Mars

P.S. Pour les pierres il y a aussi les frais d'essais à payer. Je vous écrirai là dessus

19. TO W.H.B. SANDS, LONDON

Paris 21 Mars 1898

Cher Monsieur Sands,
J'ai modifié dans le sens que vous indiquiez la biographie d'Yvette Guilbert. La seconde version a quatre pages nouvelles qui vont se souder à la cinquième et suivantes de la première version. Je crois que comme cela Yvette sera contente de vous donner sa signature. Si elle n'acceptait pas, vous pourriez vous servir de la première version est plus complète et plus amusante—il y a des détails drôles et tout à fait inédits qui pourraient amuser vos clients. Rien n'a été fait de plus intime ni de plus complet sur Yvette Guilbert. Enfin c'est à vous de choisir.
Agréez, Cher Monsieur Sands, l'assurance de mes sentiments dévoués.
Arthur Byl

20. TO W.H.B. SANDS, LONDON

[Paris] 22 Mars [1898]

Cher Monsieur
Je vous envoie aujourd'hui le texte de Byl et vous devez avoir reçu 6 pierres. J'en ai fait une autre.
Yours truly
HTLautrec

[Note at the top in a different hand (probably W. H. B. Sands)]:

[London] Mch 24 [1898]
Je viens de recevoir 6 pierres ce matin. J'attends deux encore. J'ai payé pour ces six pierres 20-0-6. Voulez vous me donner "on a/c" pour le tout c'est à dire les dessins déja faits. Je crois que ces 20-0-6 sont pour des autres dessins parce que vous me dites "payez les pierres en bloc à la fin"

21. TO H. DE TOULOUSE-LAUTREC, PARIS

London . . . Mar 25 . . . 1898

Cher Monsieur

Dans ma liste de 18 dessins Balthy ne figure pas—ainsi comme Byl a fait Balthy nous devons le substituer pour Delna—et je crois qu'on doive aussi avoir Ackté au lieu de Catulle Mendès—et avoir aussi pour faire 20 Antoine et Guitry. Qu'en pensez vous?

Très pressé

Yours truly
W H B Sands

22. TO W.H.B. SANDS, LONDON

[Paris,] Dimanche 27 Mars [1898]

Cher Monsieur

D'après votre lettre nous faisons Balthy au lieu de Delna.—C'est cela n'est ce pas.—

Envoyez moi en double la liste des articles livrés par Byl car j'ai beau tenir des livres j'ai toujours peur de me tromper. Qui preferez vous encore Sybil Sanderson ou Ackté?—

Je vous envoie le texte de Guitry aujourd'hui et le modèle du reçu d'acompte. Faut il un timbre de facture ou est ce suffisant comme cela.—?—

Les deux autres pierres d'Yvette sont prêtes. Je vous les enverrai demain—Lundi—.

Pour le prix des pierres et des essais je vous ferai un compte à part en bloc.—Cordialement à vous.

Yours truly
H de Toulouse Lautrec

23. TO W.H.B. SANDS, LONDON

[Paris] 27 Mars 1898

Reçu de M. Sands la somme de 600 f. pour 6 dessins sur pierre d'Yvette Guilbert.

Reste encore deux dessins à faire non livrés au même prix soit 100 f. chacun

H de Toulouse Lautrec
15 avenue Frochot

24. TO H. DE TOULOUSE-LAUTREC, PARIS

London . . . Mars 28 . . . 1898

Cher Monsieur

Merci de votre lettre.

La liste doit comprendre—

1 Bernhardt	
2 Rostand	
3 Coquelin	
4 Calvé	
5 Polaire	
6 d'Alençon	articles déja faits—
7 Polin	
8 Hading	
9 Marsy	
10 Balthy	
11 Mounet-Sully	
12 Guitry	
13 Ackté	
14 Held	
15 Granier	
16 Febvre	
17 Antoine	
18 Réjane	
19 Sanderson	
20 Belfort	

W H B S

25. TO W.H.B. SANDS, LONDON

[Paris] 1er Avril [1898]

Cher Monsieur

Je vous envoie ci joint la note des pierres d'Y. Guilbert essais préparatoires et pierres plus emballages. J'ai fait faire un compte à part car je ne sais si vous voulez faire imprimer les 20 autres dessins ici ou à Londres ce qui fait donc que vous me devez encore personnellement 3 Yvettes à 100 f soit 300 f. Dites moi que je dois payer l'imprimeur tout de suite.—

J'ai fait au lieu de Ackté—Cléo de Mérode. Le sujet est plus sympathique. Vous aurez lundi soit ou Mardi les epreuves de Cléo et de Sybil Sanderson. J'ai tenu à diviser les deux comptes pour éviter la confusion. Pour la signature je vais voir Yvette moi même—

Yours truly
H de T. Lautrec

[173]

26. TO W.H.B. SANDS, LONDON

Essais et préparation de 8 pierres (Dessins Yvette Guilbert)	40.00
Valeur des 8 pierres a 2f, 40c pièce	19.20
1ère Caisse d'emballage	3.90
2ème ″ ″ 	1.60
	64.70

[Paris] le 1er Avril 1898
Henry Stern

27. TO W.H.B. SANDS, LONDON

[Paris, April 4, 1898]

Cher Monsieur

Je vous envoie les dessins de Cléo de Mérode et Sybil Sanderson

Yours truly
HTLautrec

28. TO W.H.B. SANDS, LONDON

[Paris, early April 1898]

I send you back the copy with the *Ratures* of Yvette herself and the medallion of Sybil Sanderson

Yours truly
H T Lautrec

29. TO W.H.B. SANDS, LONDON

Pavillon d'Armenonville

[Paris] Jeudi 7 Avril 1898

Cher Monsieur

1600 f
en tout

J'ai reçu le chèque de 500 f de samedi et vous remercie. J'ai donc reçu de vous *600 f* pour Byl *500 f* une fois pour moi et *500 f* une autre fois pour moi ce qui fait les 8 dessins d'Yvette payés et 200 f d'avance sur le livre (*j'ai pris sur ces deux cent francs les 65 f de pierres d'essai et d'emballage à Stern*) ce qui fait donc 135 f à valoir sur nos 20 médaillons pour la part dessins. Je vous donne ce detail

pour ne pas embrouiller les deux affaires. Envoyez moi s.v.p. le texte d'Yvette pour que Byl le retouche selon vos indications. Quant à la couverture comment la voulez vous? En litho ou par le même procédé que celle du Nursery Toy Book. En noir ou en couleur? Je verrai Yvette de suite pour signature. Est'ce qu'une seule signature autographe suffirait?

si c'e[…]
neces[…]

Yours truly
H de Toulouse Lautrec

P.S. Donnez moi instructions telegraphiées pour la couverture.

H.T.L.

Renvoyez moi le texte de Sybil Sanderson, Byl en a un meilleur. Je vous envoie le médaillon de Cléo de Mérode.

30. TO W.H.B. SANDS, LONDON

Paris, April 10, 1898

Prière donner adresse Henri Perrin and Co. Je ne les connais pas. Lettre suit.

Yours truly
HTLautrec

[Note at top also by Lautrec:]

Pierre ne partira que mardi matin. Impossible avant.

31. TO W.H.B. SANDS, LONDON

Dimanche [Paris, April 10, 1898]
Cher Monsieur

Je vous ai envoyé il y a une heure un mot pour vous dire que je ne connaissais pas Henri Perin.

J'ai fini par trouver sur mes notes Hernu Péron. Comme la Maison ne m'a rien dit encore j'irai mardi et vous écrirai demain au sujet des autres questions de votre lettre aujourd'hui

Bien à vous
yours truly
H de Toulouse Lautrec

Transcriptions of the Original Letters

32. TO W.H.B. SANDS, LONDON

Paris, April 13, [18]98

Cher Monsieur

Je vous renvoie les épreuves d'Yvette. Ma couverture n'est pas terminée. Je n'ai pas eu le temps d'aller voir Hernu et Péron. Je vous écrirai demain.

Yours truly
HTLautrec

33. TO W.H.B. SANDS, LONDON

Samedi [Paris, probably April 16, 1898]

Cher Monsieur

J'ai fini par avoir les 500 f de Hernu et Péron. Ils avaient envoyé chez moi et on ne m'avait pas trouvé. J'ai donc reçu de vous

500 f
500 f
500 f soit 1500 f

et Byl 600 f—

Byl va me livrer aujourd'hui le reste des médaillons de la liste du 28 mars. J'ai vu Yvette Guilbert qui arrive à Londres dans q.q. jours. Elle debute le 2 mai le jour de l'ouverture de mon exposition. J'arriverai à Londres le lundi 25 avril et nous causerons. Yvette m'a dit qu'elle signera ce qu'on voudra. Voulez vous pour l'édition courante qu'elle signe sur du papier autographique et vous ferez un report. Je vous ai envoyé la couverture. Est ce bien. J'ai laissé la place de la lettre en blanc. Repondez moi s.v.p. et dites moi si vous pouvez m'envoyer des épreuves du texte de Byl pour les montrer à Yvette.

Yours truly
H de Toulouse Lautrec

34. TO W.H.B. SANDS, LONDON

Dimanche [Paris, probably April 24, 1898]

Cher Monsieur

Je vous envoie les derniers médaillons de Byl. Je regrette que la couverture n'ait pas pu

servir. Je ferai signer Yvette aujourd'hui sur papier autographique et vous n'aurez qu'a le faire reporter sur pierre. Je signerai aussi de la même façon

Yours truly
HTLautrec

35. TO (W.H.B. SANDS, LONDON)

[London, April 30, 1898]

Goupil Gallery
5 Regent Street
Henri De Toulouse Lautrec

Saturday 30

36. TO ARTHUR BYL, PARIS

London . . . 1ere . . . Mai . . . 1898

Mons Byl

Cher Monsieur Byl

M. Lautrec m'a dit qu'il vous a donné 100 fr. pour 4 médaillons. Il reste encore 9 à payer, et je vous envoie cheque pour 225 francs. Pour le présent j'ai assez de médaillons, parce que je ne me suis pas encore décidé sur les autres dessins. Alors je n'aurai pas besoin d'autres médaillons pour le présent. Je vous ecrirai sur ce sujet plus tard.

Agréez, Monsieur, l'assurance de mes sentiments les plus respectueux.

W H B Sands

37. TO [W.H.B. SANDS, LONDON]

[London, May 2, 1898]

Goupil Gallery
5 Regent Street

Henri De Toulouse-Lautrec

Admit Two

Monday 2

[175]

38. TO H. DE TOULOUSE-LAUTREC
At 317, Charing Cross Hotel, London

Karlsbad, May 6, [18]98

Cher Monsieur

Nous sommes à Carlsbad! La dame avait des douleurs telles que les medecins l'ont immédiatement fait partir de Paris!

J'ai dû remettre à l'année prochaine ma Saison à Londres, mon cher mari préférant que je me soigne de suite! Et voilà! Amitiés
Yvette [Guilbert]

39. TO W.H.B. SANDS, LONDON

[Paris] 11 Mai 1898

Cher Monsieur

Je vous envoie deux lithographies Cheval et Chien. Pouvez vous les montrer à M. Brown et demandez lui si avec ces épreuves là *coloriées* ou d'autres même style on peut faire quelque chose et dans quelles conditions. Je préférerais tirage limité sur du très beau papier chaque épreuve entre 2 et 4 livres[1b]— half and half c'est à dire avec 50 pour % de remise.

Un mot s.v.p. et beaucoup d'amitiés
Yours truly
HTLautrec

40. TO W.H.B. SANDS, LONDON

Paris, May 20, [18]98

Dear Sir

Avez vous reçu les deux dessins de chevaux? Je vous serai très obligé de me le dire au plus tôt car je vais partir à la campagne.
Yours truly
HTLautrec

41. TO W.H.B. SANDS, LONDON

[Paris] 30 mai [1898]

Cher Monsieur

Je vous serais très obligé de me dire si vous avez reçu toutes les pierres (15) et les 4 dernières épreuves. Je pars pour la mer et ai besoin de tout régler ici. Un mot s.v.p. et yours truly
H. de T. Lautrec

42. TO H. DE TOULOUSE LAUTREC, PARIS

London . . . May 31 . . . 1898

Cheque 300 fr. inclus

Cher Monsieur

I have rec'd 4 stones.

Balthy I am afraid will be no use, so I am returning it to MM Stern. I think that MM Stern must have made a mistake in charging 5 fr. ea. for 15 tirages. I am writing to them on the matter.

On May 1st I wrote to Byl that I did not require any more medallions for the present, so I shall not be able to use the two on Held & Belfort. I wrote him very distinctly, so I cannot understand why he has done or is doing any more. Belfort is quite unknown here, except to a few, all about Held that is necessary I can write myself . . .

J'ai maintenant 14 dessins qui suffiseront pour le present. Nous pourrons arranger pour quelques autres dans l'automne.
[no signature
W. H. B. Sands]

43. TO W.H.B. SANDS, LONDON

Paris, June 7 [18]98

Cher Monsieur

Gardez Balthy pour le moment. Tant mieux si vous la faites paraître. Écrivez moi à ce sujet

Yours truly
HTLautrec

Transcriptions of the Original Letters

44. TO W.H.B. SANDS, LONDON

[Paris] 14 juin [18]98

Messieurs

M. de Toulouse Lautrec me prie de vous écrire pour justifier le prix que vous trouvez trop élevé pour les 15 pierres que je vous ai envoyées le 25 Mai dernier.

Je suis sûr que n'importe qui vous aurait demandé 6 francs par pierre au lieu de 5 francs. Toutes les pierres ont été préparées 2 fois, nettoyer doubler et dedoubler pour l'emballage.

Croyez Messieurs que je ne cherche nullement à vous faire payer plus cher qu'à mes clients car je travaille beaucoup meilleur marché que mes confrères, et en demandant 75 francs pour 15 pierres dessins je ne crois pas qu'il y a à redire.

Dans l'espoir de vous lire
croyez moi Messieurs
votre dévoué

Henry Stern
83 faubourg St Denis
Paris

[Note by person in Sands's office:]
June 18/98
Send corrected inv. only ordered 14 stones

45. TO W.H.B. SANDS, LONDON

[Paris, October 28, 1899]

Cher Monsieur

Voici la lettre en question selon votre désir. Tout va bien et j'espère bientôt vous lire. Nous travaillons de nouveau et j'ai un livre de 20 à 25 planches en couleur about circus qui va paraître chez Joyant Manzi and Co.

Yours truly
H de T. Lautrec

46. TO W.H.B. SANDS, LONDON

Paris, Le 28 octobre 1899

Je declare par la présente avoir vendu à M. Sands editeur à Londres le portrait de Polaire qui a été reproduit dans le Paris Magazine et ce dessin appartient par consequent à M. Sands en toute propriété

Henry de Toulouse Lautrec
15 av. Frochot Paris

47. TO W.H.B. SANDS, LONDON

Paris, 3 Février 1900

P.S.

Ils ont promis en plus un article de rectification envoyez le moi s.v.p.

Yours
HTL

Cher Monsieur

Je crois que nous ne pouvons pas désirer mieux que ce que le Daily Mail a fait.

Je vous serre la main bien cordialement et vous remercie de votre appui dans cette affaire

Yours truly
HTLautrec

Transcriptions of the Arthur Byl Biographies

TRANSCRIPTIONS OF
THE ARTHUR BYL BIOGRAPHIES

CLÉO DE MÉRODE

On a fait de Mlle Cléo de Mérode l'héroine d'une foule d'histoires à dormir debout. Il n'y en a pas une authentique. Oui, oui, c'est certain, un royal spectateur, très enthousiaste, lui proposa de quitter Paris pour Bruxelles; mais tout se borne à cela.

Si on connait Mlle de Mérode sous toutes ses faces physiques, et, cela surtout, grâce à la statue du maître sculpteur Falguière, qui nous la révèla dans une personnification de la danse, où elle démontra qu'elle n'avait rien à cacher, il n'en va pas de même de sa vie intime.

On ignore à peu près tout d'elle. Elle est née en Belgique, cela est certain, où? Problème. Elle affirme avoir 23 ans, croyons-la. A ce compte, elle serait entrée dans la classe de danse de l'opéra de Paris, à l'âge de huit ans. Il y a trois ans qu'elle est sujet, c'est à dire danseuse de premier plan. Elle est très modeste, malgré le bruit fait autour d'elle, très bonne camarade, on l'adore au foyer.

Signe particulier: Est toujours escortée de Mme sa mère, une baronne pour de bon, paraît-il. Tout est possible.

GUITRY

Lucien Germain Guitry est né à Paris le 13 Décembre 1860. Entre au conservatoire en 1876 dans la classe de Monrose, en sort en 1878 avec un deuxième prix de comédie et un deuxième prix de tragédie. Débute au Gymnase dans la *Dame aux Camélias*, rôle d'Armand Duval, 1er octobre 1878. Crée *l'âge ingrat*, 1878, le *Fils de Coralie* 1880. Quitte le Gymnase en 1881. Passe plusieurs années en Russie où il joue tout le répertoire français. Est obligé de partir de St Pètersbourg à la suite d'une altercation suivie de pugilat avec le Grand duc Wladimir, frère de l'Empereur. Son altesse impériale eut les yeux pochés, le comédien en fut quitte pour quelques horions et un order à avoir à quitter la Russie dans les 24 heures.

Guitry entre à l'Odéon, en 1891; y reprend *Amoureuse, Kean*. Passe au *grand Théâtre*, en 1892, y crée *Lysistrata, Pécheur d'Islande*. De là il va à la Renaissance ou il joue *Les Rois, Izail, Gismonda, Amphitrion* et tout dernièrement *Les Mauvais Bergers*, d'Octave Mirbeau.

BALTHY

Née à Bayonne en 1867 de pauvres ouvriers tisserands qui possédaient déjà douze enfants.

Fut employée dans un magasin de deuil aux appointements de 40 francs par mois. Débute à l'Eldorado sans succès. Entre ensuite à la *Scala* avec 90 francs par mois. Va de là au *Palais Royal* dans la figuration, y reste trois ans. Enfin trouve sa voie aux *Menus Plaisirs* ou elle triomphe.

Très fantasque, un peu garçonne. Maigre, plûtot laide. A une maladie d'estomac. As-

sure l'existence d'une quinzaine de parents: frères, neveux etc.

Possède une fort jolie voix, sait s'en servir avec adresse. Après un séjour aux Variétés s'adonne à la création de courtes revues, qu'elle joue à la Bodinière et surtout dans les salons mondains avec son camarade Fordyce, auteur et acteur.

M. L. MARSY

De son vrai nom Anne-Marie-Louise-Joséphine Brochard. Née à Paris le 20 Mars 1866. 1er Prix de comédie au Conservatoire, en 1883, classe de M. Delaunay. Débute à la Comédie Française dans le *Misanthrope,* le 22 Décembre 1883. Joue ensuite le *Mariage de Figaro.* Abandonne le théâtre en 1886. Y rentre en 1888 pour créer *la grande Marinière* à la Porte-Saint-Martin. Revient à la Comédie-Française, en 1890. Est nommé sociétaire en 1891.

S'occupe, en dehors du théâtre, de sport hippique. A une écurie coûteuse. Elle peut se permettre ce luxe. A gagné la forte somme dans la fréquentation d'un bon petit jeune homme, mort aujourd'hui, qui possédait une cinquantaine de millions.

La femme la plus détestée de Paris.

POLIN

Pierre-Paul Marsalès, dit Polin.

Né à Paris, le 13 août 1863. Elève à la Manufacture des Gobelins. Débute au concert de la Pépinière le 4 Septembre 1886; y reste à peine un mois. Passe ensuite au concert du Point-du-Jour, trois mois; puis à l'Eden-Concert, cinq ans. Ensuite à l'Alcazar d'Été, puis entre au Théâtre des Nouveautés où il triomphe dans *Champignol malgré lui.* Il avait un engagement de cinq ans qu'il résilie au bout de six mois. M. Marchand, le manager des Folies-Bergères de la Scala et de l'Eldorado, lui faisant un pont d'or. Il paye un dédit de 15.000 francs, gagne quatre cents francs par soirée à identifier le troupier français dans ses ridicules et ses naivetés.

EMILIENNE D'ALENÇON

Née en 1869. Fut inscrite sur les actes de l'état civil sous le nom de son père, un pauvre ouvrier charpentier, qui s'appelait modestement Legros.

Connut des années de misères noires alors qu'elle était apprentie, puis ouvrière blanchisseuse.

Fait du théâtre a coté. Il serait trop hardi de dire qu'elle a du talent; a mieux que cela: Elle est belle; et même quand elle bredouille en scène est violemment applaudie.

Bonne fille, un peu avare. D'ici quelques années se retirira de la vie publique: ira vivre à la campagne; donnera le dimanche, à la messe, le pain béni.

MOUNET-SULLY

Né à Bergerac, le 27 Février 1841. Fit de fortes études à Toulouse et vint à Paris concourir pour le Conservatoire malgré la volonté de se parents. Après deux ans

d'études obtient un prix de tragédie, et est engagé à l'Odéon en 1868, où il joue le *Roi Lear, Le Batard* et *Lucrèce* sans attirer particulièrement l'attention. Fut mis en relief par quelques créations heureuses aux matinées Ballande. Débute aux Français en 1872, dans le rôle d'Oreste. Succès prodigieux.

Gâte des dons très réels par une vanité excessive. S'attira d'Emile Augier, pendant une répétition de *Jean de Thomeray,* la verte observation qui suit.

"Pour Dieu, Monsieur, tâchez d'avoir un peu moins de génie et un peu plus de talent!"

Cela peint l'homme.

JANE HADING

Jeannette Hadingue, dite Jane Hading, est née à Marseille le 25 novembre 1861. Paraît à Marseille à l'âge de trois ans, dans le rôle de la Poupée, du *Bossu.* Fit toutes ses études musicales et dramatiques au conservatoire de sa ville natale, ou elle obtint un prix de solfège. Va à Alger où elle joue le *Passant, les deux orphelins, Ruy Blas.* Après un court

séjour au Palais-Royal de Paris, passe au Gymnase Dramatique où elle crée la *Petite mariée.* Joue ensuite les pièces de Daudet, d'Ohnet, de Claretie. Se marie à son directeur Koning, divorce deux ans après; entre à la Comédie Française. Quitte la maison de Molière, en 1895, à la suite d'une violente altercation avec Mlle Marsy.

SELECTED BIBLIOGRAPHY

CONCORDANCE

INDEX

Selected Bibliography

ADHÉMAR, JEAN. *Toulouse-Lautrec, Lithographies, Pointes Sechès—Oeuvre Complet.* Arts et Métiers Graphiques, Paris, 1965.

ADRIANI, GÖTZ, and WOLFGANG WITTROCK. *Toulouse-Lautrec—Das Gesamte Graphische Werk.* Dumont Buchverlag, Cologne, 1976.

ANTOINE, ANDRÉ. *Mes Souvenirs sur Le Théâtre-Libre.* Arthème Fayard & Cie., Paris, 1921.

ANTOINE, ANDRÉ. *Mes Souvenirs sur Le Théâtre Antoine et Sur l'Odéon.* Bernard Grasset, Paris, 1929.

Catalogue. Musée Toulouse-Lautrec, Albi, 1973.

COURSAGET, RENÉ, and MAX GAUTHIER. *Cent Ans de Théâtre par la Photographie.* Editions l'Image, Paris, 1947.

DELTEIL, LOYS. *Le Peintre-Graveur Illustré XIX et XX Siècles,* Vols. X and XI: H. De Toulouse-Lautrec. Chez l'Auteur, Paris, 1920.

DORTU, M. G. *Toulouse-Lautrec et Son Oeuvre,* Six Vols. Collector's Editions, New York, 1971.

GOLDSCHMIDT, LUCIEN, and HERBERT SCHIMMEL. Eds. *Unpublished Correspondence of Henri de Toulouse-Lautrec.* Phaidon, London, 1969.

GOLDSCHMIDT, LUCIEN, and HERBERT SCHIMMEL. Eds. *Henri de Toulouse-Lautrec: Lettres 1871–1901.* Gallimard, Paris, 1972.

GUILBERT, YVETTE, and HAROLD SIMPSON. *Yvette Guilbert: Struggles and Victories.* Mills and Boon Ltd., London, 1910.

GUILBERT, YVETTE. *The Song of My Life, My Memories,* translated by Béatrice de Holthoir. George G. Harrap & Co., Ltd., London, 1929.

GUITRY, SACHA. *If Memory Serves.* Doubleday, Doran & Co., New York, 1936.

HELD, ANNA. *Mémoires.* La Nef de Paris Éditions, Paris, 1954.

HUISMAN, P. H., and M. G. DORTU. *Lautrec Par Lautrec.* Edita Lausanne, La Bibliothèque des Arts, Paris, 1964.

JOYANT, MAURICE. *Henri de Toulouse-Lautrec 1864–1901.* Vol. I, Peintre; Vol. II, Dessins—Estampes—Affiches. H. Floury, Editeur, Paris, 1926, 1927.

KNAPP, BETTINA, and MYRA CHIPMAN. *That Was Yvette.* Holt, Rinehart and Winston, New York, 1964.

Selected Bibliography

LE ROY, GEORGE. *Music Hall Stars of the Nineties*. British Technical and General Press, London, 1952.

MACK, GERSTLE. *Toulouse-Lautrec*. Alfred A. Knopf, New York, 1938.

MARTIN, JULES. *Nos Artistes: Portraits et Biographies*. P. Ollendorff, Edit., Paris, 1895.

MARTIN, JULES. *Nos Auteurs et Compositeurs Dramatiques*. Ernest Flammarion, Edit., Paris, 1897.

MARTIN, JULES. *Nos Artistes: Annuaire de Théâtres, 1901-1902*. Lib. P. Ollendorff, Paris, 1901.

DE MÉRODE, CLÉO. *Le Ballet de Ma Vie*. Pierre Horay, Paris. 1955.

Le Panorama. Nos Jolies Actrices: Paris s'amuse; Les Cafés Concerts. Librarie d'art Ludovic Baschet, Éditeur, Paris, various dates.

Le Panorama. Paris La Nuit. Librarie d'art Ludovic Baschet, Éditeur, Paris, various dates.

POTIN, FELIX (collection). *500 Célébrités Contemporaines*. Paul Jouet, Paris, n.d.

QUÉANT, GILLES. *Encyclopédie du Théâtre Contemporain*. Les Publications de France, Paris, 1957.

RENARD, JULES. *Journal*. Gallimard, Paris, 1935.

Revue d'Art Dramatique. Nouvelle Série, Tome III. Janvier-Mars 1898, Paris.

ROUSSOU, MATEI. *André Antoine*, L'arche, Paris, 1954.

SKINNER, CORNELIA OTIS. *Elegant Wits and Grand Horizontals*. Houghton Mifflin Company, Boston, 1962.

Le Théâtre. Première Année 1898. Goupil & Cie., Paris, 1898.

Concordance

Numbers from the catalogue by Loys Delteil are used as references in the text and notes. The corresponding numbers in the two other standard catalogues (see Selected Bibliography, page 187) can be found in this concordance which follows.

Example: Using line 2:

> Delteil 2 is Adhémar 279 and Adriani/Wittrock 246. Adhémar 2 is Delteil 11 and Adriani/Wittrock 3. Adriani/Wittrock 2 is Delteil 340 and Adhémar 4.

The asterisk (*) signifies an item which does not appear in that catalogue. Example: Using line 10, Delteil 10 does not appear in Adriani/Wittrock.

Concordance

	DELTEIL SEQUENCE		ADHÉMAR SEQUENCE		ADRIANI-WITTROCK SEQUENCE	
	A	A-W	D	A-W	D	A
1	274	245	339	1	339	1
2	279	246	11	3	340	4
3	280	247	12	4	11	2
4	275	248	340	2	12	3
5	277	249	342	7	343	6
6	281	250	343	5	344	7
7	278	251	344	6	342	5
8	276	252	39	8	39	8
9	282	253	352	109	341	11
10	16	*	17	10	17	10
11	2	3	341	9	345	12
12	3	4	345	11	346	13
13	17	16	346	12	347	14
14	40	38	347	13	348	15
15	148	137	348	14	349	71
16	72	71	10	*	13	17
17	10	10	13	16	28	28
18	19	28	27	37	29	29
19	20	29	18	28	30	30
20	21	30	19	29	31	31
21	25	31	20	30	32	32
22	23	32	23	33	33	35
23	22	33	22	32	34	38
24	26	34	25	35	35	36
25	24	35	21	31	36	33
26	27	36	24	34	37	37
27	18	37	26	36	38	34
28	28	17	28	17	18	19
29	29	18	29	18	19	20

Concordance

	DELTEIL SEQUENCE		ADHÉMAR SEQUENCE		ADRIANI-WITTROCK SEQUENCE	
	A	A-W	D	A-W	D	A
30	30	19	30	19	20	21
31	31	20	31	20	21	25
32	32	21	32	21	22	23
33	35	22	36	25	23	22
34	38	23	38	27	24	26
35	36	24	33	22	25	24
36	33	25	35	24	26	27
37	37	26	37	26	27	18
38	34	27	34	23	14	40
39	8	8	56	54	63	41
40	43	42	14	38	54	60
41	44	43	63	39	53	59
42	45	44	64	76	40	43
43	46	45	40	42	41	44
44	47	46	41	43	42	45
45	48	47	42	44	43	46
46	49	48	43	45	44	47
47	50	49	44	46	45	48
48	51	50	45	47	46	49
49	52	51	46	48	47	50
50	53	52	47	49	48	51
51	55	53	48	50	49	52
52	56	64	49	51	50	53
53	59	41	50	52	51	55
54	60	40	65	55	56	39
55	63	62	51	53	65	54
56	39	54	52	64	351	68
57	62	60	266	285	76	67
58	76	63	227	282	350	70

Concordance

	DELTEIL SEQUENCE		ADHÉMAR SEQUENCE		ADRIANI-WITTROCK SEQUENCE	
	A	A-W	D	A-W	D	A
59	125	67	53	41	353	69
60	64	70	54	40	57	62
61	65	69	294	61	294	61
62	66	68	57	60	55	63
63	41	39	55	62	58	76
64	42	76	60	70	52	56
65	54	55	61	69	116	105
66	84	74	62	68	165	104
67	74	73	76	57	59	125
68	73	72	351	56	62	66
69	75	75	353	59	61	65
70	78	101	350	58	60	64
71	77	99	349	15	16	72
72	79	100	16	71	68	73
73	82	97	68	72	67	74
74	81	96	67	73	66	84
75	80	95	69	75	69	75
76	67	57	58	63	64	42
77	109	105	71	99	79	86
78	110	106	70	101	80	87
79	86	77	72	100	81	88
80	87	78	75	95	82	89
81	88	79	74	96	83	90
82	89	80	73	97	84	91
83	90	81	145	98	85	92
84	91	82	66	74	86	93
85	92	83	*	*	87	94
86	93	84	79	77	88	95
87	94	85	80	78	89	96

Concordance

	DELTEIL SEQUENCE		ADHÉMAR SEQUENCE		ADRIANI-WITTROCK SEQUENCE	
	A	A-W	D	A-W	D	A
88	95	86	81	79	90	97
89	96	87	82	80	91	98
90	97	88	83	81	92	99
91	98	89	84	82	93	100
92	99	90	85	83	94	101
93	100	91	86	84	95	102
94	101	92	87	85	96	103
95	102	93	88	86	75	80
96	103	94	89	87	74	81
97	107	323	90	88	73	82
98	108	104	91	89	145	83
99	106	102	92	99	71	77
100	112	103	93	91	72	79
101	123	110	94	92	70	78
102	131	118	95	93	99	106
103	134	119	96	94	100	112
104	128	115	165	66	98	108
105	129	116	116	65	77	109
106	127	114	99	102	78	110
107	130	117	97	323	127	111
108	138	123	98	104	355	115
109	135	122	77	105	352	9
110	126	113	78	106	101	123
111	113	130	127	107	144	137
112	117	128	100	103	128	142
113	114	129	111	130	110	126
114	321	364	113	129	106	127
115	143	139	355	108	104	128
116	105	65	354	136	105	129

Concordance

	DELTEIL SEQUENCE		ADHÉMAR SEQUENCE		ADRIANI-WITTROCK SEQUENCE	
	A	A-W	D	A-W	D	A
117	121	131	112	128	107	130
118	118	132	118	132	102	131
119	122	133	120	134	103	134
120	119	134	121	135	163	132
121	120	135	117	131	164	133
122	*	*	119	133	109	135
123	124	144	101	110	108	138
124	140	124	123	144	124	140
125	139	125	59	67	125	139
126	141	126	110	113	126	141
127	111	107	106	114	175	215
128	142	112	104	115	112	117
129	158	147	105	116	113	114
130	159	148	107	117	111	113
131	153	149	102	118	117	121
132	163	150	163	120	118	118
133	154	151	164	121	119	122
134	155	152	103	119	120	119
135	151	153	109	122	121	120
136	161	154	190	164	354	116
137	157	155	144	111	15	148
138	156	156	108	123	356	149
139	164	157	125	125	115	143
140	165	158	124	124	357	147
141	152	159	126	126	358	150
142	162	160	128	112	173	195
143	160	162	115	139	362	189
144	137	111	146	192	123	124
145	83	98	147	193	366	188

Concordance

	DELTEIL SEQUENCE		ADHÉMAR SEQUENCE		ADRIANI-WITTROCK SEQUENCE	
	A	A-W	D	A-W	D	A
146	144	192	148	325	176	196
147	145	193	357	140	129	158
148	146	325	15	137	130	159
149	183	168	356	138	131	153
150	166	266	358	141	132	163
151	167	267	135	153	133	154
152	174	268	141	159	134	155
153	169	269	131	149	135	151
154	178	270	133	151	136	161
155	177	271	134	152	137	157
156	173	272	138	156	138	156
157	171	273	137	155	139	164
158	172	274	129	147	140	165
159	176	275	130	148	141	152
160	175	276	143	162	142	162
161	170	277	136	154	267	318
162	168	278	142	160	143	160
163	132	120	132	150	293	233
164	133	121	139	157	190	136
165	104	66	140	158	361	198
166	217	201	150	266	167	190
167	190	166	151	267	195	186
168	216	203	162	278	149	183
169	218	204	153	269	194	191
170	211	188	161	277	191	192
171	214	189	157	273	192	193
172	361	288	158	274	193	194
173	195	142	156	272	196	185
174	317	176	152	268	363	220

Concordance

	DELTEIL SEQUENCE		ADHÉMAR SEQUENCE		ADRIANI-WITTROCK SEQUENCE	
	A	A-W	D	A-W	D	A
175	215	127	160	276	364	197
176	196	146	159	275	174	317
177	213	190	155	271	179	200
178	212	191	154	270	180	201
179	200	177	265	284	181	202
180	201	178	264	283	182	203
181	202	179	262	280	183	204
182	203	180	263	281	184	205
183	204	181	149	168	185	206
184	205	182	359	194	186	207
185	206	183	196	173	187	208
186	207	184	195	167	188	209
187	208	185	360	195	189	210
188	209	186	366	145	170	211
189	210	187	362	143	171	214
190	136	164	167	166	177	213
191	192	170	194	169	178	212
192	193	171	191	170	146	144
193	194	172	192	171	147	145
194	191	169	193	172	359	184
195	186	167	173	142	360	187
196	185	173	176	146	200	224
197	221	324	364	175	198	222
198	222	197	361	165	199	223
199	223	198	365	202	201	225
200	224	196	179	77	202	226
201	225	199	180	178	166	217
202	226	200	181	179	365	199
203	295	296	182	180	168	216

Concordance

	DELTEIL SEQUENCE		ADHÉMAR SEQUENCE		ADRIANI-WITTROCK SEQUENCE	
	A	A-W	D	A-W	D	A
204	229	205	183	181	169	218
205	231	206	184	182	204	229
206	230	207	185	183	205	231
207	232	208	186	184	206	230
208	258	209	187	185	207	232
209	257	212	188	186	208	258
210	252	210	189	187	210	252
211	253	211	170	188	211	253
212	264	239	178	191	209	257
213	305	354	177	190	292	329
214	236	236	171	189	326	227
215	235	234	175	127	218	260
216	228	237	168	203	219	322
217	271	244	166	201	235	240
218	260	215	169	204	236	241
219	322	216	*	303	237	246
220	272	240	363	174	238	248
221	268	241	197	324	239	244
222	270	242	198	197	240	249
223	269	243	199	198	241	242
224	300	308	200	196	242	247
225	319	314	201	199	243	243
226	291	302	202	200	244	245
227	58	282	326	214	245	250
228	266	322	216	237	246	237
229	265	321	204	205	247	238
230	273	298	206	207	248	239
231	298	297	205	206	249	*
232	283	254	207	208	320	251

Concordance

	DELTEIL SEQUENCE		ADHÉMAR SEQUENCE		ADRIANI-WITTROCK SEQUENCE	
	A	A-W	D	A-W	D	A
233	297	299	293	163	335	254
234	292	295	295	238	215	235
235	240	217	215	234	286	294
236	241	218	214	236	214	236
237	246	219	246	228	216	228
238	248	220	247	229	295	234
239	244	221	248	230	212	264
240	249	222	235	217	220	272
241	242	223	236	218	221	218
242	247	224	241	223	222	270
243	243	225	243	225	223	269
244	245	226	239	221	217	271
245	250	227	244	226	1	274
246	237	228	237	219	2	279
247	238	229	242	224	3	280
248	239	230	238	220	4	275
249	*	231	240	222	5	277
250	306	255	245	227	6	281
251	307	256	320	232	7	278
252	308	257	210	210	8	276
253	309	258	211	211	9	282
254	310	259	335	233	232	283
255	311	260	296	355	250	306
256	312	265	289	293	251	307
257	313	261	209	212	252	308
258	314	262	208	209	253	309
259	315	263	283	306	254	310
260	316	264	218	215	255	311
261	302	279	323	307	257	313

Concordance

	DELTEIL SEQUENCE		ADHÉMAR SEQUENCE		ADRIANI-WITTROCK SEQUENCE	
	A	A-W	D	A-W	D	A
262	181	280	321	349	258	314
263	182	281	327	305	259	315
264	180	283	212	239	260	316
265	179	284	229	321	256	312
266	57	285	228	322	150	166
267	318	161	322	350	151	167
268	320	363	221	241	152	174
269	359	313	223	243	153	169
270	304	309	222	242	154	178
271	303	311	217	244	155	177
272	290	310	220	240	156	173
273	301	312	230	298	157	171
274	367	352	1	245	158	172
275	358	351	4	248	159	176
276	360	353	8	252	160	175
277	328	316	5	249	161	170
278	327	317	7	251	162	168
279	365	356	2	246	261	302
280	364	357	3	247	262	181
281	362	358	6	250	263	182
282	363	359	9	253	227	58
283	259	306	232	254	264	180
284	288	290	336	287	265	179
285	289	289	291	286	266	57
286	294	235	287	291	291	285
287	286	291	288	292	336	284
288	287	292	284	290	172	361
289	256	293	285	289	285	289
290	324	315	272	310	284	288

Concordance

	DELTEIL SEQUENCE		ADHÉMAR SEQUENCE		ADRIANI-WITTROCK SEQUENCE	
	A	A-W	D	A-W	D	A
291	285	286	226	302	287	286
292	329	213	234	295	288	287
293	233	163	330	294	289	256
294	61	61	286	235	330	293
295	234	238	203	296	234	292
296	255	355	*	300	203	295
297	333	326	233	299	231	298
298	334	327	231	297	230	273
299	335	328	328	304	233	297
300	336	329	224	308	*	296
301	337	330	273	312	329	301
302	338	331	261	279	226	291
303	339	332	271	311	*	219
304	340	333	270	309	328	299
305	341	334	213	354	327	263
306	343	335	250	255	283	259
307	342	336	251	256	323	261
308	344	337	252	257	224	300
309	345	338	253	258	270	304
310	346	339	254	259	272	290
311	347	340	255	260	271	303
312	348	341	256	265	273	301
313	349	342	257	261	269	359
314	350	343	258	262	225	319
315	351	344	259	263	290	324
316	352	345	260	264	277	328
317	353	346	174	176	278	327
318	354	347	267	161	324	357
319	355	348	225	314	331	356

Concordance

	DELTEIL SEQUENCE			ADHÉMAR SEQUENCE			ADRIANI-WITTROCK SEQUENCE	
	A	A-W		D	A-W		D	A
320	251	232		268	363		332	326
321	262	349		114	364		229	265
322	267	350		219	216		228	266
323	261	307		367	360		97	107
324	357	214		290	315		197	221
325	370	362		329	301		148	146
326	227	214		332	320		297	333
327	263	305		278	317		298	334
328	299	304		277	316		299	335
329	325	301		292	213		300	336
330	293	294		337	*		301	337
331	356	319		338B	*		302	338
332	326	320		338	*		303	339
333	368	365		297	326		304	340
334	369	366		298	327		305	341
335	254	233		299	328		306	343
336	284	287		300	329		307	342
337	330	*		301	330		308	344
338	332	*		302	331		309	345
339	1	1		303	332		310	346
340	4	2		304	333		311	347
341	11	9		305	334		312	348
342	5	7		307	336		313	349
343	6	5		306	335		314	350
344	7	6		308	337		315	351
345	12	11		309	338		316	352
346	13	12		310	339		317	353
347	14	13		311	340		318	354
348	15	14		312	341		319	355

Concordance

	DELTEIL SEQUENCE		ADHÉMAR SEQUENCE		ADRIANI-WITTROCK SEQUENCE	
	A	A-W	D	A-W	D	A
349	71	15	313	342	321	262
350	70	58	314	343	322	267
351	68	56	315	344	275	358
352	9	109	316	345	274	367
353	69	59	317	346	276	360
354	116	136	318	347	213	305
355	115	108	319	348	296	255
356	149	138	331	319	279	365
357	147	140	324	318	280	364
358	150	141	275	351	281	362
359	184	194	269	313	282	363
360	187	195	276	353	367	323
361	198	165	172	288	368	366
362	189	143	281	358	325	370
363	220	174	282	359	268	320
364	197	175	280	357	114	321
365	199	202	279	356	333	368
366	188	145	368	361	334	369
367	323	360	274	352	—	—
368	366	361	333	365	—	—
369	—	—	334	366	—	—
370	—	—	325	362	—	—

Index

Index

Index

Index

Index